Lacock

TEN LANDSCAPES

TEN LANDSCAPES
RAYMOND JUNGLES

EDITED BY JAMES GRAYSON TRULOVE

Photography by Lanny Provo

Text by Stephen Dunn

Rockport Publishers, Inc.
Rockport, Massachusetts

First published in the United States of America by:

Rockport Publishers, Inc.
33 Commercial Street
Gloucester, Massachusetts 01930-5089
Telephone: (978) 282-9590
Facsimile: (978) 283-2742

Distributed to the book trade and art trade in the
United States by:

North Light Books, an imprint of
F & W Publications
1507 Dana Avenue
Cincinnati, Ohio 45207
Telephone: (800) 289-0963

Other distribution by:

Rockport Publishers, Inc.
Gloucester, Massachusetts 01930-5089

ISBN 1-56496-613-5

10 9 8 7 6 5 4 3 2

Design: James Pittman
Cover Image: Lanny Provo

Dedicated to the memory and living gift of Roberto Burle Marx.

James Grayson Trulove is a magazine and book publisher and
editor in the fields of landscape architecture, art, graphic
design, and architecture. He is publisher and co-founder of
Spacemaker Press, an imprint specializing in books on land-
scape art and architecture. His most recent books are *The
New American Garden* (Whitney, 1998) and *The New American
Cottage* (Whitney, 1999). Trulove is a recipient of the Loeb
Fellowship from Harvard University's Graduate School of
Design. He resides in Washington, D.C.

CONTENTS

Foreword by Rosemary Barrett Seidner

Selected Works

FOREWORD

by Rosemary Barrett Seidner

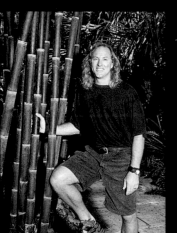

Paradise—it's an abstract concept for most, an ideal for many, and a goal perhaps for all. Whether one strives for paradise as a state of mind or a state of being, its achievement demands serenity, harmony, tranquillity, peace, and calm. Raymond Jungles ASLA, deeply understands the concept and delivers paradise to his clients as an environment for mind and being. His extraordinary creativity and strong visual sensibility combined with his mastery of tropical and sub-tropical plant materials shape his designs with clarity and confidence just as a visual artist boldly colors a canvas, or brings form and life to a block of granite. The result is gardens of natural, unforced majesty enriched by their own growth, feted by their climate, and celebrated by those who are inspired by the new world that grows up around them.

It has been my good fortune over the years to have written about the private gardens designed by Raymond Jungles, and to have shared the public spaces that have come to vibrant, verdant life from his Miami/Key West drawing boards. I have known Raymond and his artist wife, Debra Yates, the designer and creator of the vivid tile murals often seen in his designs, since their very earliest days of landscape collaborations. It is also my great privilege to have known Raymond's mentor, "father of modern landscape architecture", legendary Brazilian artist and landscape architect, Roberto Burle Marx (1909-1994), a giant of a man who considered both Raymond and his wife his protegee—one in the field of landscape architecture, the other, as a visual artist.

It was meeting Burle Marx at a lecture in 1979, after having already read about his work, that forcefully swayed the then-23-year-old Jungles away from study-

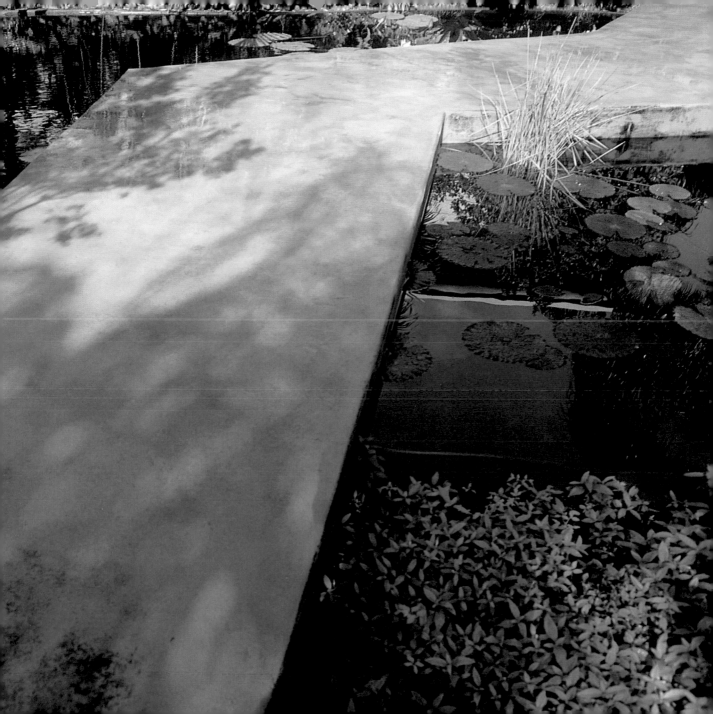

ing architecture to studying landscape architecture. Seeing and understanding how Burle Marx could fuse structural design with nature, how he sculpted his gardens through his brilliant use of volumetric relationships, cleared Jungles' vision for a non-formulaic approach to an artful garden. This vision revels in the character of its plants, defends itself against manicuring, lives for its climate, has depth, volume and color in abundance, and ultimately extends an irresistible invitation to glory in the pure joy and harmony of nature.

Having formed a strong bond of friendship and mutual respect with Burle Marx, both Jungles and Yates made annual pilgrimages to Brazil to work and study with the master at his remarkable home and expansive gardens on the outskirts of Rio de Janeiro. They joined him in making intensive forays into the Brazilian outback in search of rare and new plant species that would ultimately expand the palette of materials suitable for inclusion in Jungles' South Florida and Caribbean landscapes. The foundation of his designs is undoubtedly native plants and trees, but well-deserved accolades are given to an extensive array of appropriate exotics that are placed as thoughtfully as one places sculpture. Like his mentor, he views art and environment as one, giving his gardens form and composition that translates readily from his artistic renditions to finished site.

The most enduring aspect of any artist's work is its ability to achieve an identity all its own. This is a particularly challenging task for the landscape architect. Site, climate, architecture, the clients--all play an important role in what must be integrated to create a whole. The unique identity of each Jungles garden becomes apparent the moment one enters it. His gardens are dramatic yet inviting; they flatter you, pulling

...ow in, making you aware of yourself, the plants surrounding you, the house, walls, gates, murals, air, sky, light, and shadow. Yet these gardens are natural places, uncontrived, appearing as if they had always been there and always will be there.

Although raised primarily in the Midwest and southern California, Jungles is intensely in tune with the tropical environment he chose to live and work in 25 years ago. A graduate with honors (Bachelors Degree in Landscape Architecture) from the University of Florida, Gainesville, Jungles made his voice heard clearly to those who count at an early age with his presentation of his senior thesis, Bayfront Park System: A Pedestrian Celebration, to prominent Miami city activists. Bringing City of Miami officials to rapt attention, the thesis was heralded in the press, its ideas taken into consideration in the ongoing long-term creation of a bayfront park whose designers include Isamu Noguchi and Burle Marx.

Jungles' love affair with South Florida and the tropics continues unabated. He rejoices in the fact that the subtle changes in seasons afford him the luxury of designing landscapes for year-round color and extravagant foliage. He is also enamored by the region's golden light and he uses it to full impact in his designs, encouraging it to filter through trees and fronds, to ripple across ground plantings and pathways, or play boldly on walls of his design, the varying planes of which are inspired by the work of Luis Barragan. Yet he appreciates that the tropical light can be harsh, and so uses light-absorbing colors and indigenous materials such as natural keystone for hardscapes. Lighting does not end with sunset, so he places up-lights and down-lights to bring man-made moon-shadows, romance and

ABOVE: *Miami oolite stone path in the Spanish Tropical garden.*
OPPOSITE PAGE: *(Top) Frond of* Licula spinosa. *(Bottom)* Philodendron 'Weeks Red Hybird'.

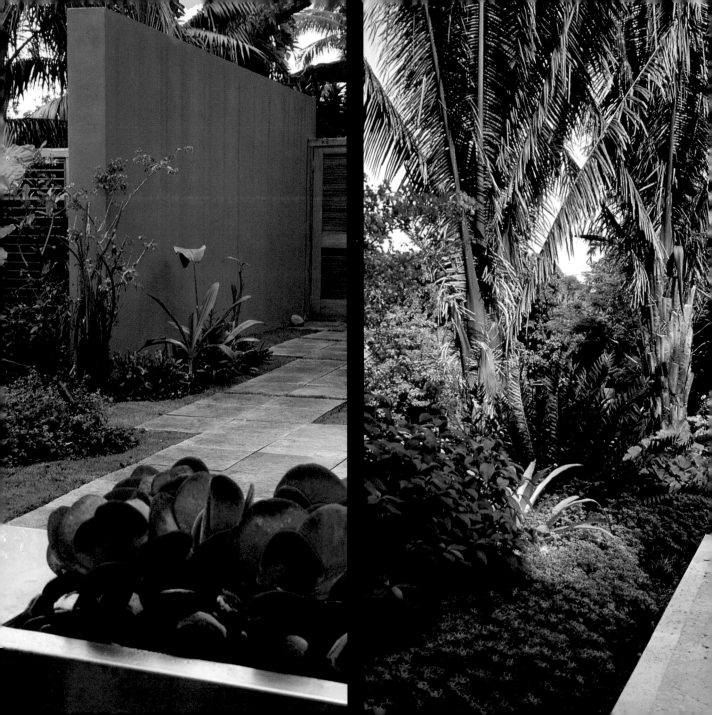

drama to the scene. Because Florida is so flat, lacking in the natural vistas afforded by hills and mountains, Jungles compensates by capturing the sky and clouds in reflecting pools of various forms or frames them with trees, fronds, and walls to give added depth and dimension to the setting.

Utilizing the indigenous plants of the wild Florida hammock for their strength and beauty, Jungles designs defensively for "insufficient maintenance" because that is so often what a garden gets. He makes use of dramatic sculptural plants that evolve to their optimum size and shape without requiring pruning or shaping. Hardy indigenous ground covers and grasses reduce the need for watering and fertilizing.

With more than 70 private residential gardens to his credit plus 11 resort hotels, many planned communities, and commercial /office sites, his list of clients reads like the who's who of South Florida. Jungles' work has been published in numerous magazines in the United States and Europe, as well as in several books. His work has been recognized with 12 awards from the Florida Chapter of the American Society of Landscape Architects, nine of which were Awards of Excellence. There have also been awards from American Resort Development Association, Florida Nurserymen's and Grower's Association, and Associated Landscape Contractors of America (Environmental Improvement Grand Award for Ocean Reef Club, 1995—post Hurricane Andrew).

Rosemary Barrett Seidner is the former managing editor of South Florida Home and Garden *and* South African Garden and Home; *an international freelance contributor; and coordinator/manager of exhibitions of contemporary art traveling to museums nationwide.*

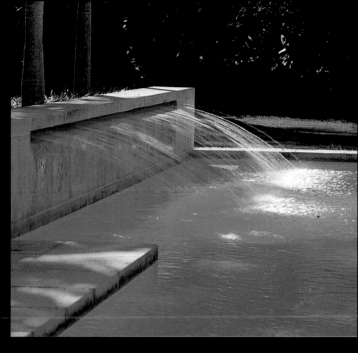

ABOVE: *Fountain jet detail, the Young garden.*
OPPOSITE PAGE: *(Left) Jungles/Yates garden in Key West. (Right) South American oil palms, the Spanish Tropical garden.*

SPANISH TROPICAL GARDEN

Southern Florida

The renovation of this garden and residence involved several programmatic elements, including the addition of a new pool, pool house and recreation pavilion, and incorporation of a large spider-shaped sculpture.

"My first concern," says Jungles, "was to bring back the grandeur of the house and its historic walls so that all the elements of the project could relate to each other."

He designed a green plaza to replace the existing circular driveway and crowded foundation plantings at the front of the house. He then created a dramatic garden gateway that mirrors the scale and the stone of the Spanish colonial home's front entrance.

"I wanted a ceremonial entrance to the spectacular space at the back of the house where art, architecture, and garden design mix in a way that manages to be both contemporary and traditional."

ABOVE: *An intimate seating space was incorporated into a quiet area of the front garden. The Cycad in the middle ground is an* Encephalartos ferox *from Southern Africa.*
OPPOSITE PAGE: *An elevated plane of zoysia grass and saturnia stone replaced the existing circular driveway. Keystone from the previous driveway was reused for the parking court.*

RIGHT: *Two South American oil palms frame a view of the front door.*

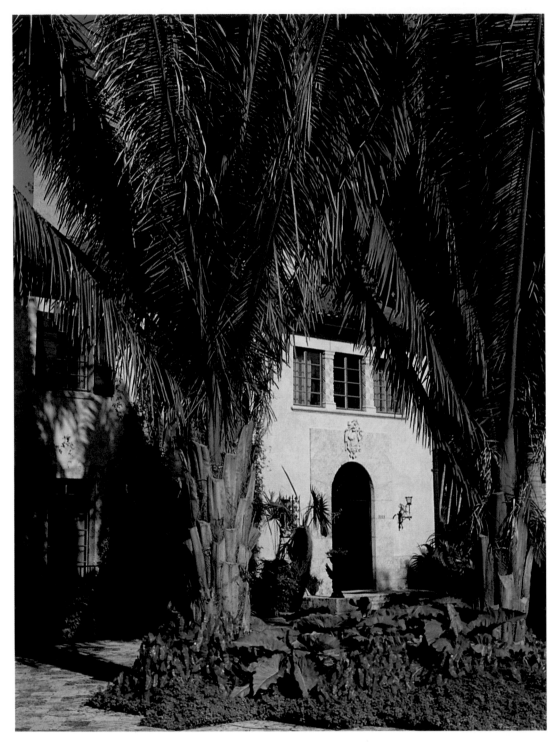

The garden has an incredible palette of plant materials with contrasting and complementing textures and volumes. South American oil palms, tropical black bamboo, and an African Mahogany tree create an enormous scale that helps put the house and spider-like sculpture, emerging from a bed of—what else?—variegated spider plant, into proper perspective.

"The diversity and juxtaposition of materials in this garden help blend the noble architecture of the original house with the more modern design of the pool house and swimming pool," says Jungles.

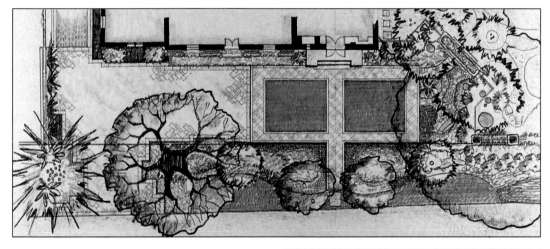

ABOVE: *Drawing of the original front garden concept. The proposed large canopy tree shown on the left was replaced by two South American oil palms to balance the large African mahogany tree on the right.*
LEFT: *Detail of stone walk.*

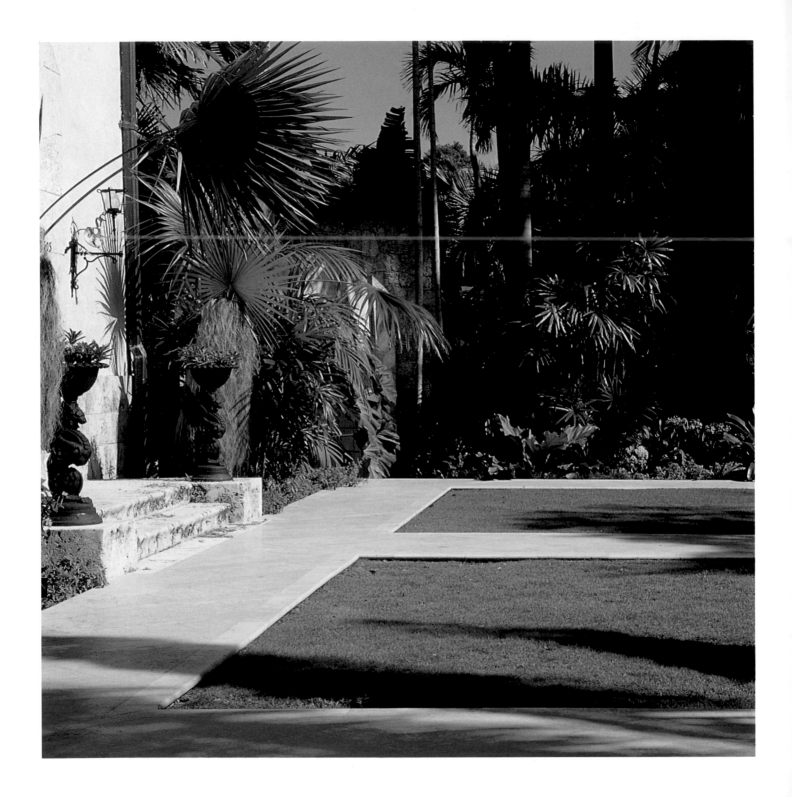

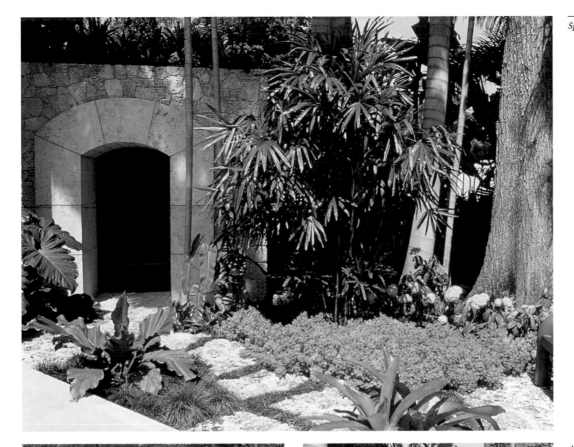

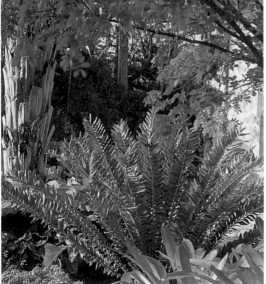

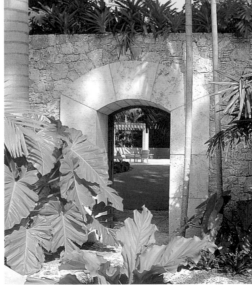

ABOVE: *Flagstones of hand-hewn indigenous oolitic limestone link the sitting area, gateway, and zoysia grass plaza.*

LEFT: *Orange Bromeliads in foreground are* Aechmea blanchettiana *'Orange Form' from Brazil.*

RIGHT: *The large-leaf plant climbing the royal palm is* Philodendron wilsoni. *Jungles brought this and many other plants, usually as cuttings, from Roberto Burle Marx's garden in Brazil.*

OPPOSITE PAGE: *Zoysia grass and saturnia stone plaza. The fuzzy palms on the left are* Coccothrinax crinita *from Cuba.*

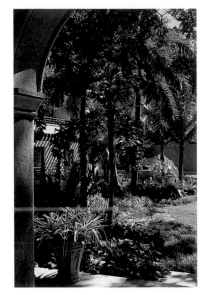

ABOVE: *View toward the grotto garden from the loggia. The Bromeliad in the pot is* Neorgelia *spp. 'Bossa Nova'.*
RIGHT: *Original concept plan of the rear garden. The large, level lawn area serves as a green patio for entertaining.*
OPPOSITE PAGE: *(Left) View from the grotto garden toward the open lawn. The strong swath of color in the center is the rhizomaceous Begonia 'Black Velvet.'.*

(Right) View from the rear garden toward the front garden.

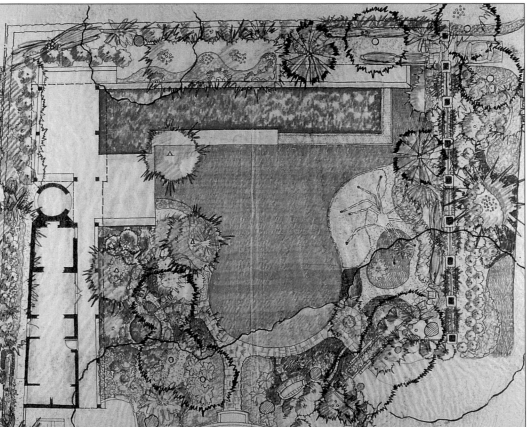

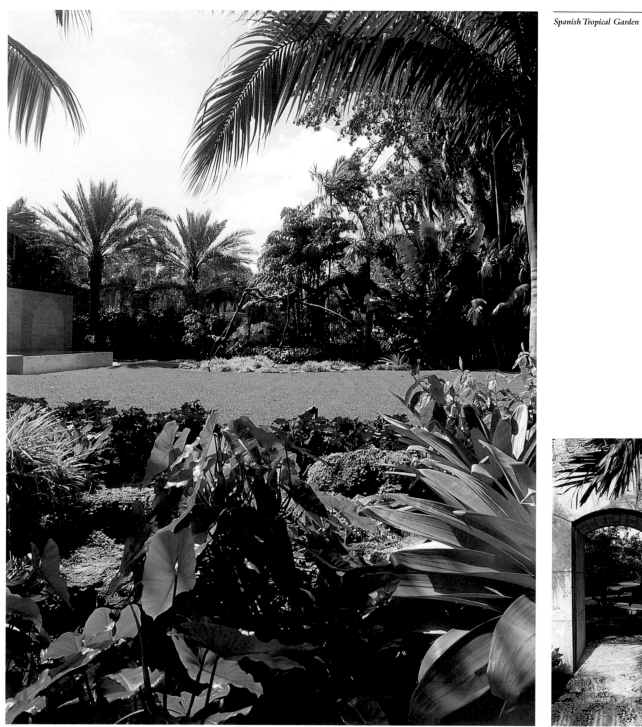

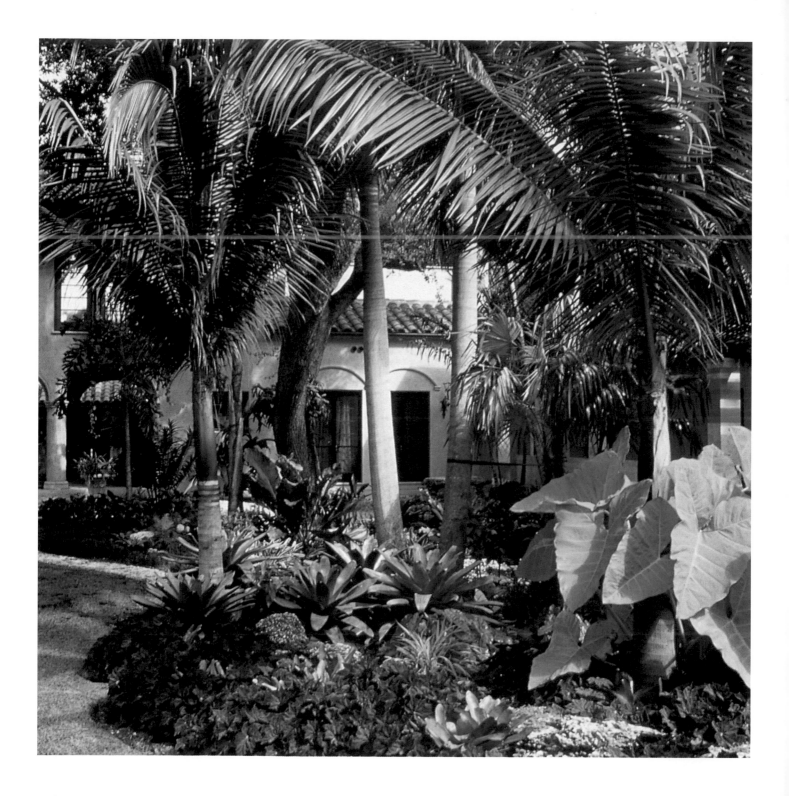

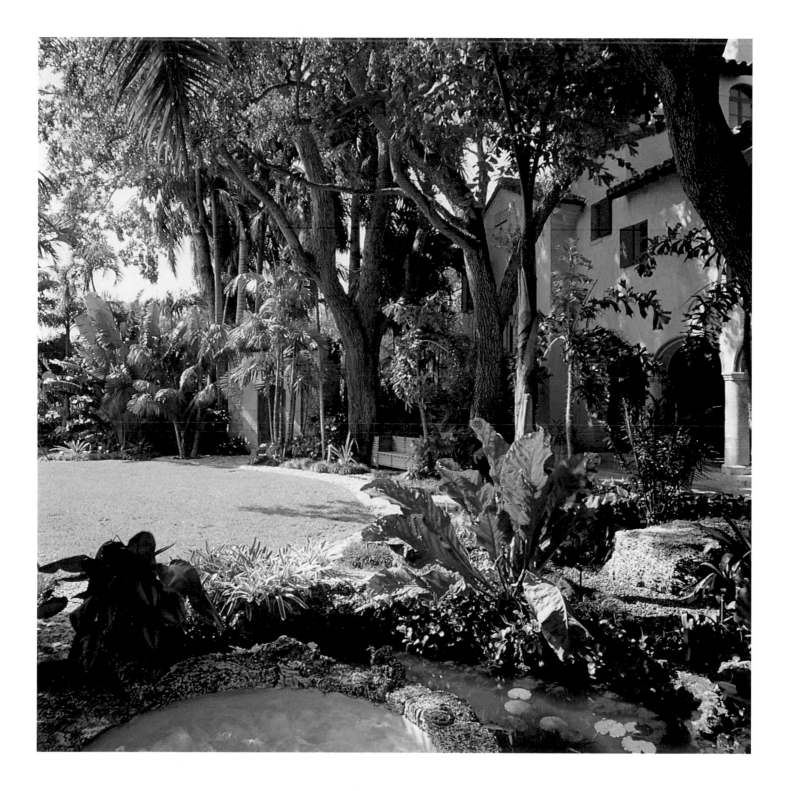

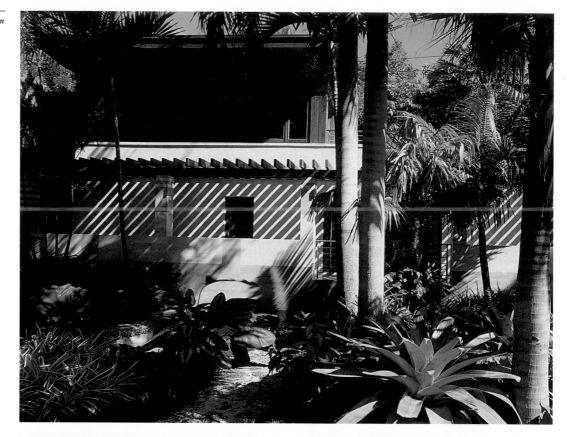

ABOVE: *The pool house/recreation pavilion was designed by architect William Bialosky in collaboration with artist Jackie Ferrara.*
LEFT: *View of the grotto pond and pool house/recreation pavilion.*
RIGHT: *Huge, majestic live oak trees provide the proper light and moisture for the understory plantings to flourish. Large boulders function as resting places.*

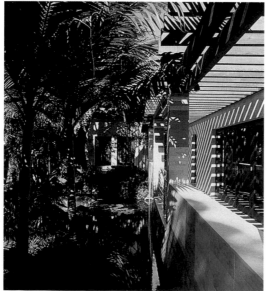

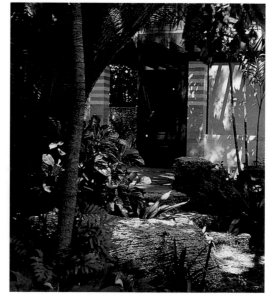

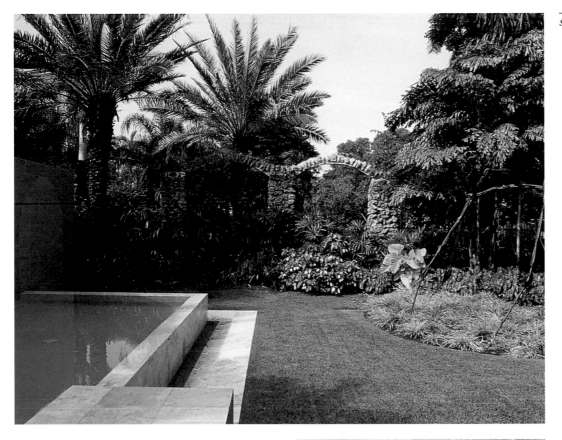

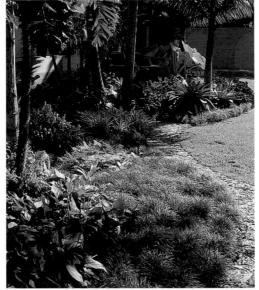

ABOVE: *View of the lap pool (designed by architect Bialosky in collaboration with artist Ferrara), the historic stone wall, and a sculpture by Louise Bourgeois. Variegated spider plant and river rock paths form the ground plane beneath the sculpture.*

LEFT: *The hand-hewn oolite stone path functions as a boarder for the lawn and as an access to the spa and to the gateway.*

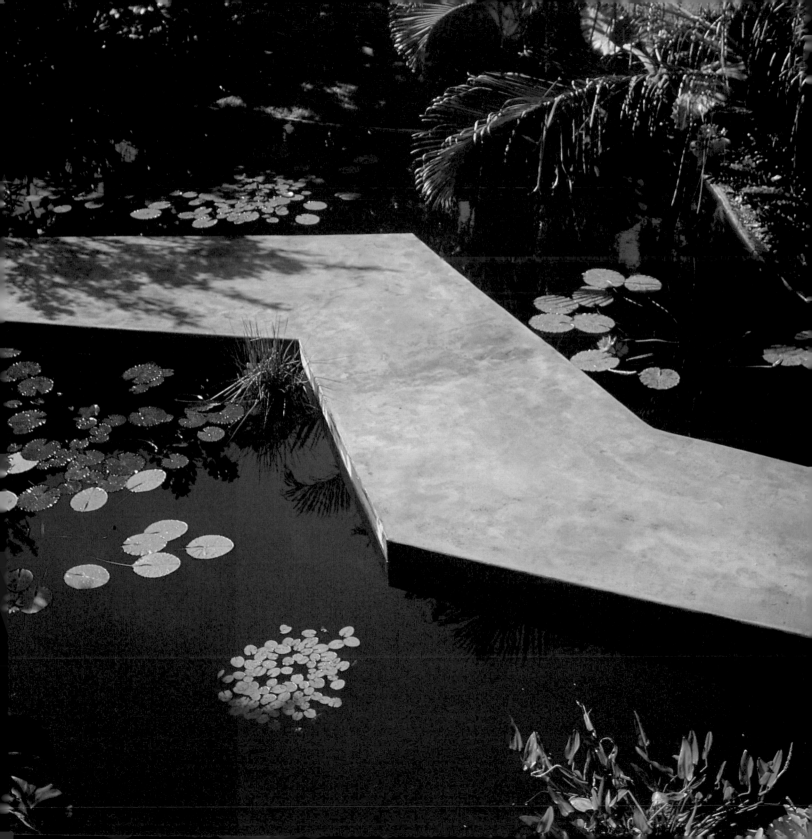

MONTIFIORE GARDEN

Miami Beach, Florida

ABOVE: *A bold and colorful bridge lands on a "beach" of pebbles set in matching grout. Random pre-cast concrete pavers complete the walkway.* OPPOSITE PAGE: *The bridge leads to the front door.*

Certain elements in Jungles' designs are such natural complements to the architecture that many people believe they were pre-existing. When the owners of this 50's property restored it from a contractor's interpretation of a Mediterranean villa, it was obvious to Jungles that a water garden was the necessary element to bring the entrance into focus.

As you approach the house and cross the sculptural concrete bridge over the lily pond, the sky is reflected in the water below, creating the appearance that the ground has become the sky. You then pass through two other distinct garden "rooms" before reaching the front door.

"I have a particular obsession with entrances in all of my projects," says Jungles. "They are crucial to the way you perceive the house and the garden. They must make a statement immediately and draw you in, whether subtly or dramatically, to what is happening in this new world you're entering."

Floating, dancing concrete pavers in the rear garden accent the fifties energy of the house. Aloes, agaves, gamma grass, and purple sugar cane comprise some of the hardy plantings that meander along a sandy beach that was created amidst coconut palms and a glade of green Bismarckias.

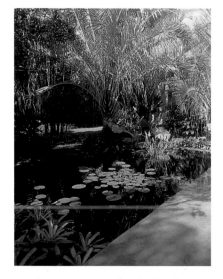

ABOVE: *Silver* Dypsis decaryi, *triangle palm from Madagascar, and* Gigantochloa atroviolacea, *tropical black bamboo, reflect in the water garden.*
RIGHT: *Original conceptual design of the front garden.*
OPPOSITE PAGE: *(Left) View from the bridge leading to the front door. The small native tree on the left,* Krugiodendron ferreum, *black iron-wood, provides a sense of mystery and softens the geometry of the bridge. (Right) The geometric golden bench by architect Glenn Heim and Victoria DiNardo-Montifiore is a charming spot for quiet reflection.*

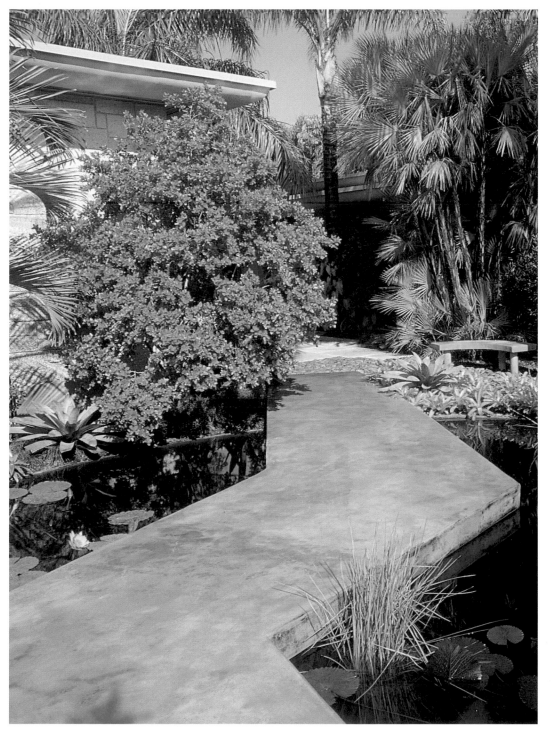

RIGHT: *Approach to the water garden from the auto court. The small tree on the left is the fragrant native* Myrcianthes fragrans, *Simpson Stopper.*

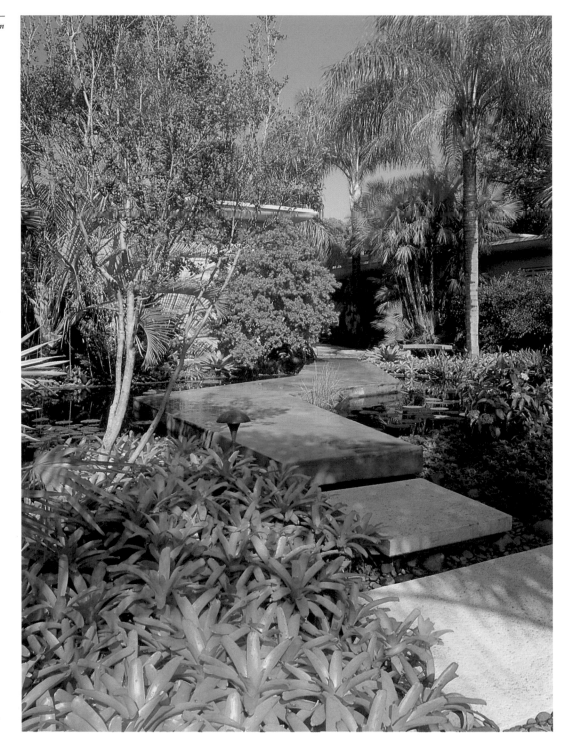

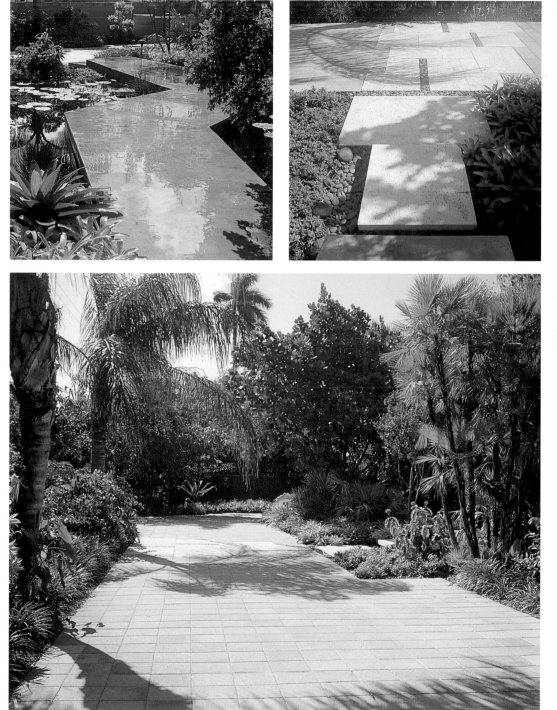

ABOVE: *(Left) Approach to the auto court from the water garden. (Right) The pre-cast concrete walkway intersects the auto court.*

LEFT: *View of the auto court. Orthogonal geometry and mixed materials give it the feeling of a pedestrian courtyard.*

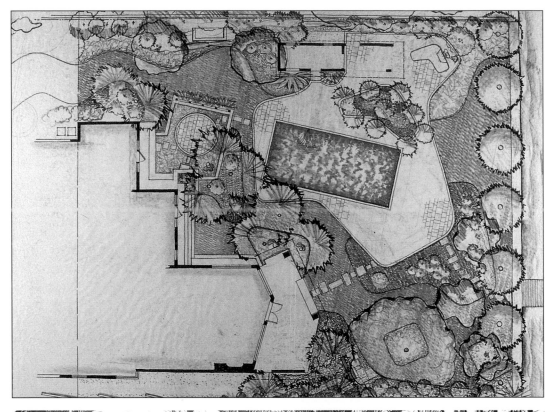

ABOVE: *Original concept drawing of the rear garden.*
RIGHT: *The trellis structure designed by architect Glenn Heim complements the fifties architecture of the house.*

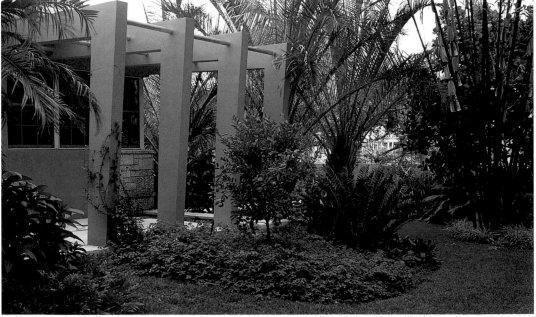

LEFT: *The specimen palm cluster is* Ptychosperma elegans, *Alexander palm, from Australia. The different colors and textures of the low mass plantings serve to anchor the existing swimming pool.*

FOLLOWING PAGES: *(Left) Free-floating concrete slabs lead from the lanai, designed by architect Glenn Heim, to the pool area and dock. (Right) The rigid and colorful Bromeliad* Aechmea *spp. 'Dennis B' contrasts with the soft, pale bamboo* Thamnocalamus siamensis. *The small shady beach area near the water's edge is another destination within the garden.*

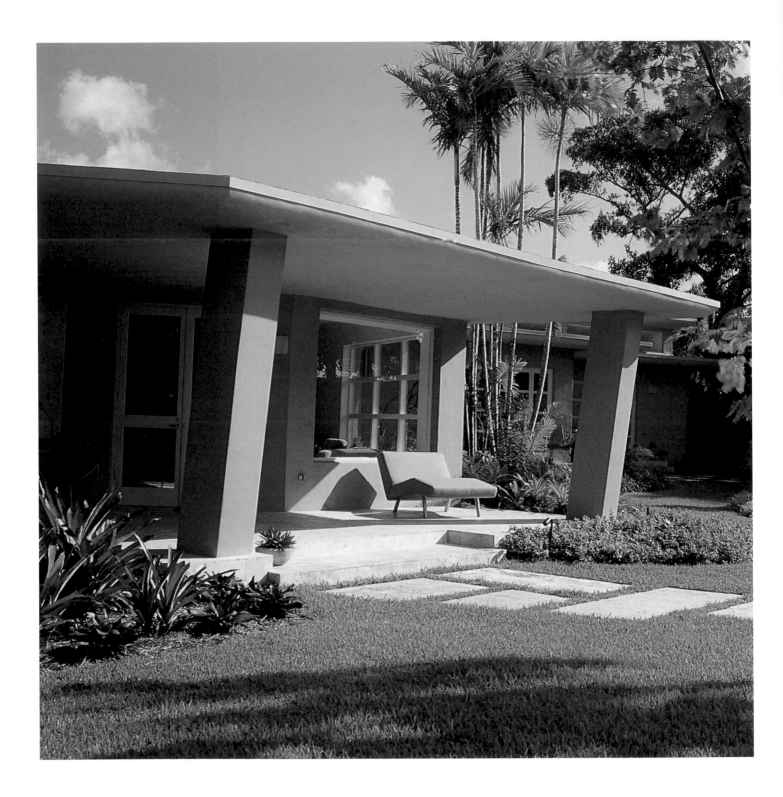

RIGHT: *A step from the media room leads down to the patio just off the master bedroom. The soft plant in the center is* Asparagus macowanii. *The philodendron on the right was brought from Roberto Burle Marx's collection.*
OPPOSITE PAGE: *Low mass plantings allow a clear view of the pool's surface, and beyond.*

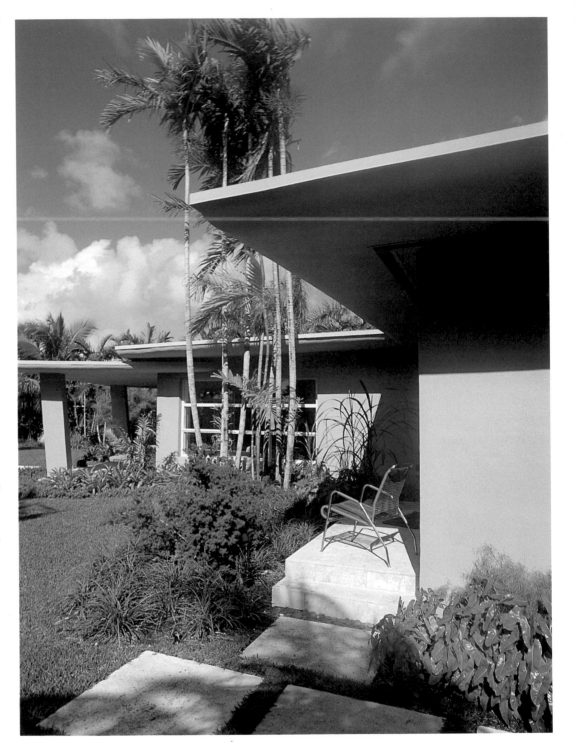

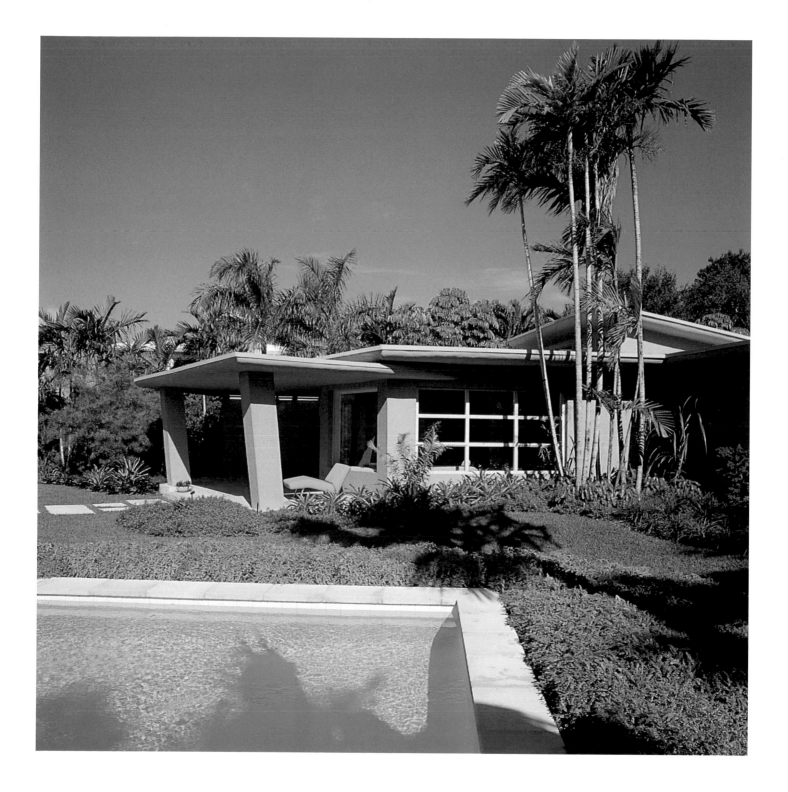

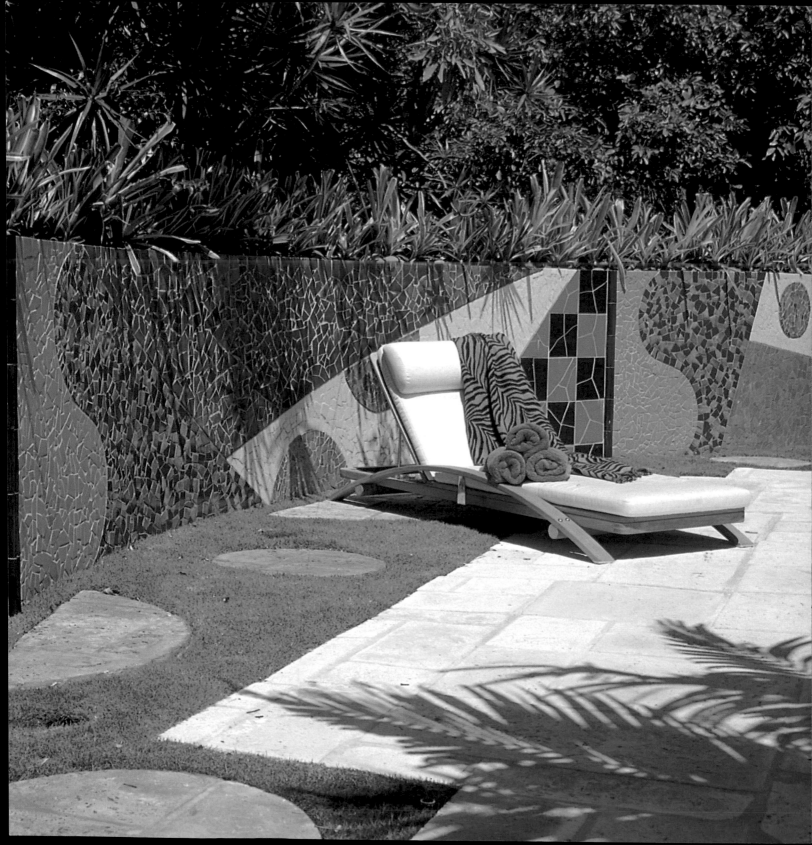

SIMS GARDEN

Coral Gables, Florida

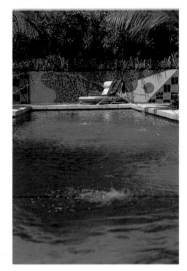

ABOVE: *The pool is finished in dark silver gray.*

OPPOSITE PAGE: *The serpentine wall with a ceramic mural by Debra Yates. Plantings behind the wall provide privacy and the height of the wall is extended with a planter of yellow Bromeliads. Zoysia grass functions as a green extension of the pool deck.*

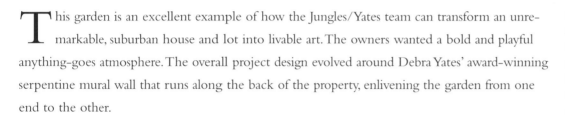

This garden is an excellent example of how the Jungles/Yates team can transform an unremarkable, suburban house and lot into livable art. The owners wanted a bold and playful anything-goes atmosphere. The overall project design evolved around Debra Yates' award-winning serpentine mural wall that runs along the back of the property, enlivening the garden from one end to the other.

"Having creative carte blanche and knowing that you would see only sections of the wall at any one time allowed me to visualize bold, crazy colors, and forms," says Yates, who was also inspired by Roberto Burle Marx. "Roberto was not afraid to use strong color or unusual geometric shapes in his gardens."

The compositional rhythm and color of the mural imparts a musical, be-bop feeling to the various spaces it inhabits. Tall colorful plantings of Tabebuia and bougainvillea behind the wall create privacy as well as the feeling that the garden backs up to the woods' edge.

The swimming pool's water jets add to the festive atmosphere. A variety of hardscape materials combined with a diverse collection of rare tropical palms, flowering trees, and indigenous plants give an overall sense of warmth and richness to the design.

The vibrant color scheme of the house and the redesigned outdoor areas help integrate the interior, the garden, and the exterior furnishings.

ABOVE: *(Left) A walkway of free-float-ing pre-cast keystone slabs creates a circuitous approach to the entrance. (Right) Palm trees enrich the front garden. The palm to the right is* Livistona rotundifolia, *from Malaya.*
RIGHT: *The garden plan allows for many different spatial experiences within the compact site.*

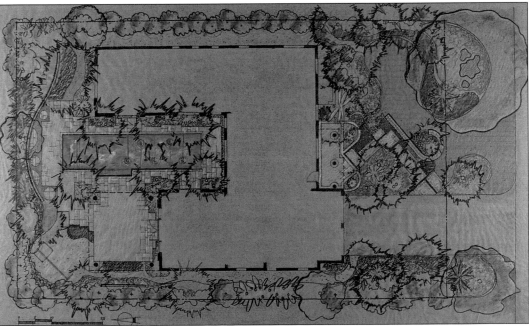

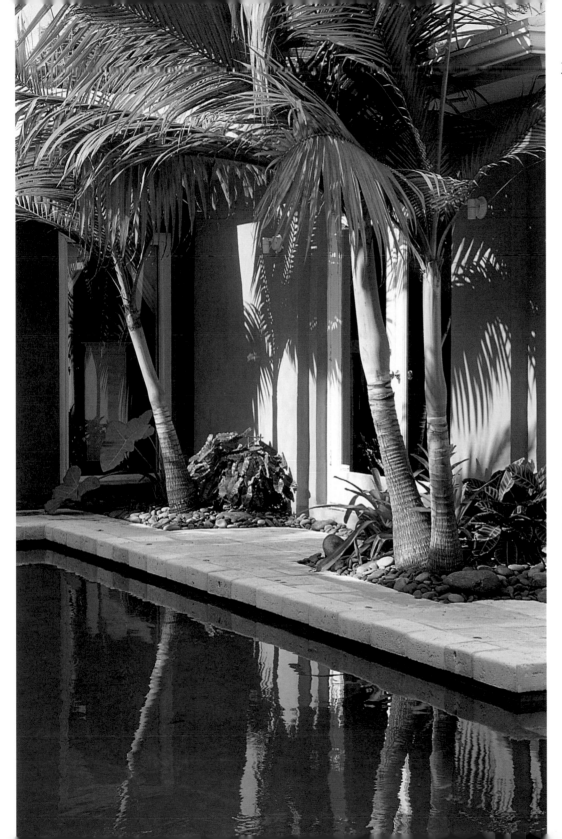

LEFT: *Multi-trunk hurricane palms,* Dictyosperma album, *from the Mascarene Islands create vibrant shadows around the pool. The playful use of color enlivens the garden.*

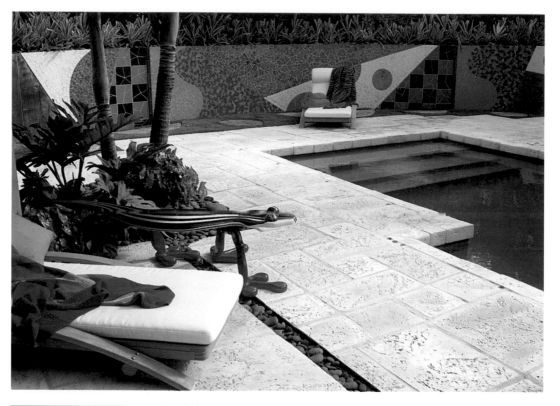

ABOVE: *View from the lanai. A seat ledge in the pool encourages conversation.*

RIGHT: *The lanai serves as an extension of the interior living room. A privacy wall incorporates moss and epiphytic plants.*

OPPOSITE PAGE: *The Jungles-designed lanai, pool deck, and pool, blend into a generous, often-used space.*

FOLLOWING PAGES: *Views of the swimming pool.*

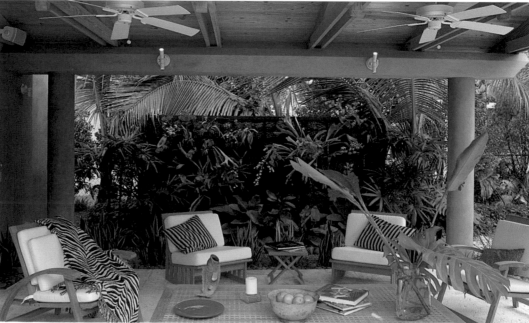

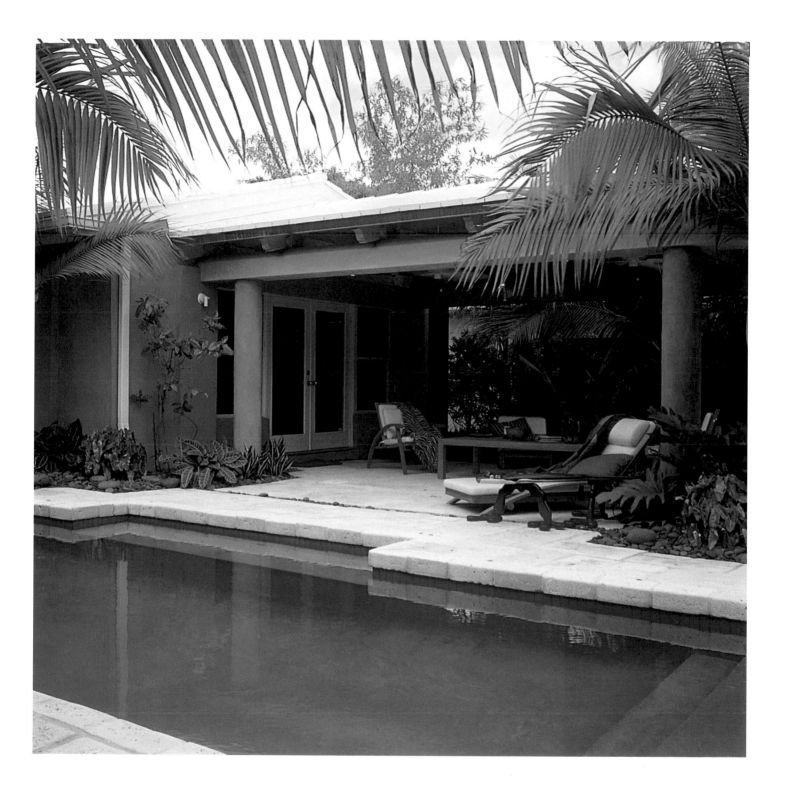

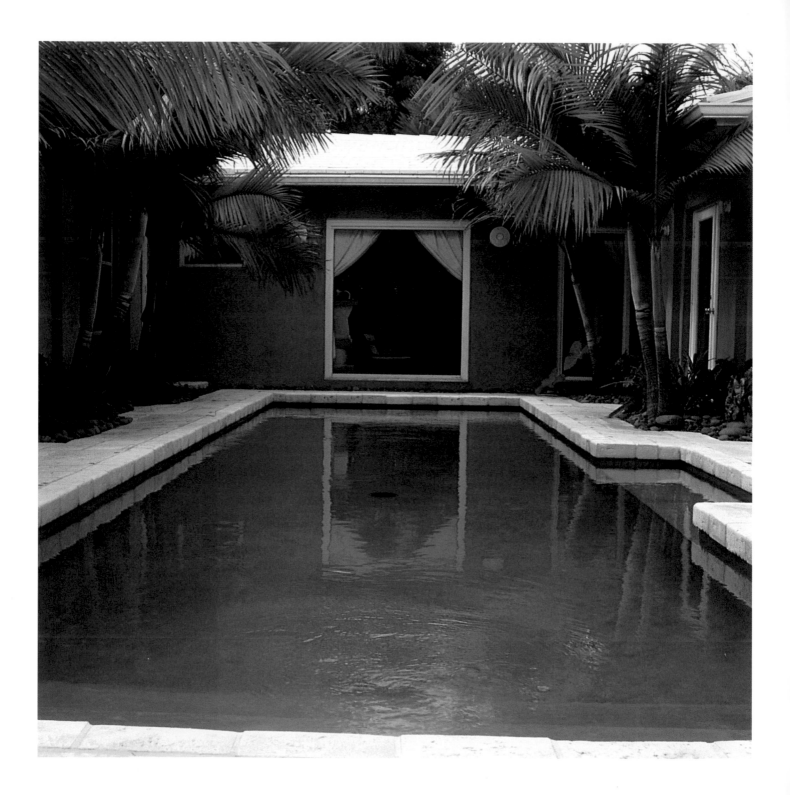

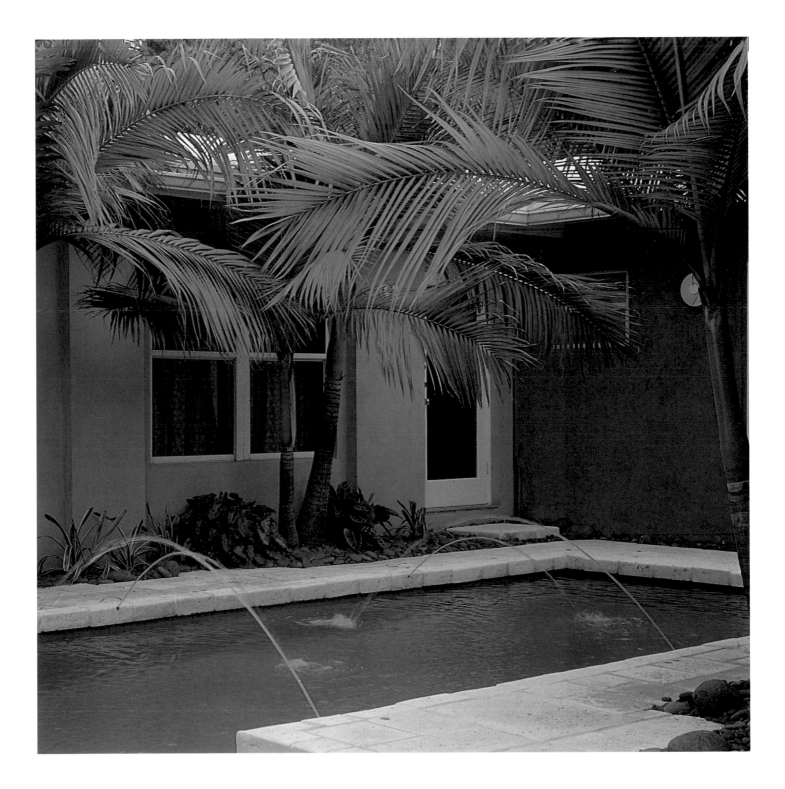

DUNN GARDEN

Key West, Florida

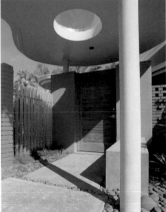

The owners of this project, who are close personal friends of Jungles and Yates, gave them creative license, requesting only that the garden be "funky, romantic, fragrant and colorful."

"Our friends' decision to purchase this house delighted us," says Jungles. "The architecture is what I call sophisticated fifties, with a George Jetson feel that I used in the design of the gatehouse and carport. Since very little had been done to the landscape since the house was built, I had a clean palette to work from."

Renovating the garage into two studios, a laundry, and a pool bath allowed the driveway space to be converted to an open lawn flanked by massive Bismarckias. Yates designed three mural walls. Two are companion murals that also serve as fountains and planters, helping to screen the property and house from a busy street. The circular drive and port cochere became a dramatic and architecturally stunning pedestrian entrance with a bright blue serpentine wall and cantilevered "potato chip" covered gatehouse with a circular skylight.

Throughout the property, dense plantings create privacy as well as myriad entertainment and sitting areas that provide completely different experiences of the house and garden. A lanai and loggia, supported by a colonnade of copper-patina colored columns, create a hierarchy of indoor/outdoor living spaces with long vistas across linear reflecting pools and palms wrapped with orchids.

"The only hazard in doing a project for close personal friends," says Jungles, "is that you begin to treat the project like your own. So we've made an agreement that the owners are just leasing the garden from me at what I think is a very reasonable rate."

TOP: *View through the roof of the gateway.* ABOVE: *The brushed aluminum fence gives the space a sense of flow yet prevents views of the private area of the garden.*
OPPOSITE PAGE: *The gateway, with its three legged canopy, provides a shaded, sheltered space at the garden's threshold.*

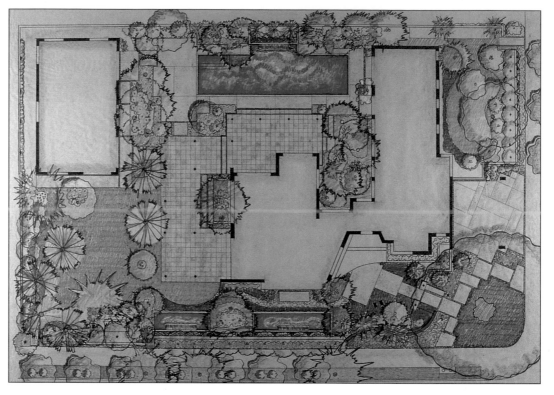

ABOVE: *The articulated walls have an identity of their own. The ground cover is a yellow Kalanchoe. The small trees, which add to the height of the privacy buffer, are native* Myrcianthes fragrans, *Simpson Stoppers.*

ABOVE RIGHT: *The garden plan.*

RIGHT: *View of the gateway. The blue serpentine wall and shelter echo the curvilinear design of the existing porte cochere roof. This area was once the parking space.*

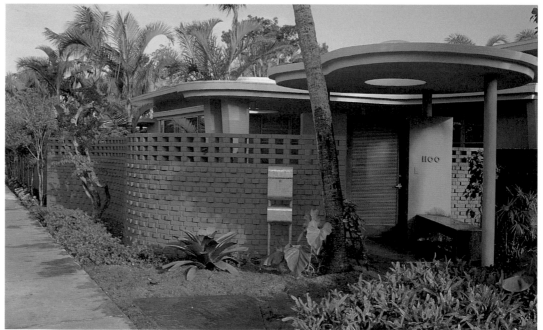

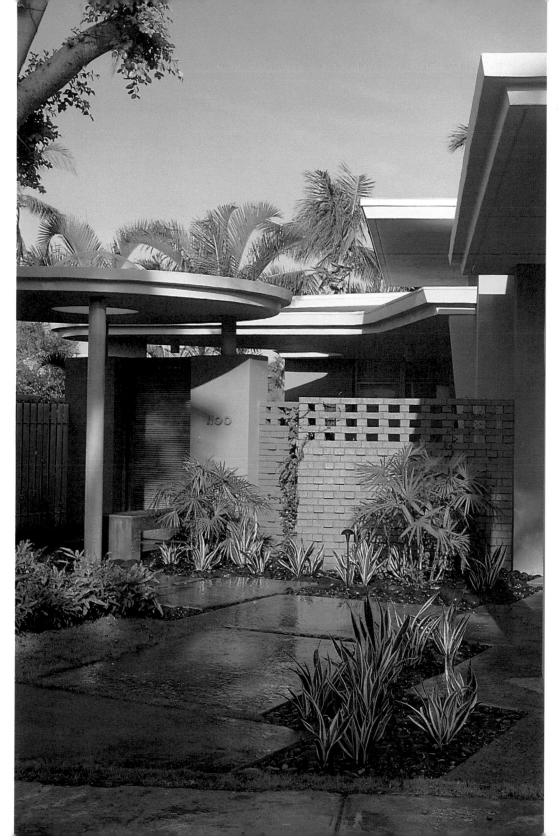

ABOVE: Sansevieria *spp.* 'Black and
Gold' emerges from a fissure filled
with river rock.

LEFT: *The former driveway has been
transformed into an inviting pedestrian
walkway. The forms of the roof planes
are repeated in the new carport at
right and at the gateway. The walkway
is made of floating slabs of concrete
with rock salt texture and a mineral
patina stain.*

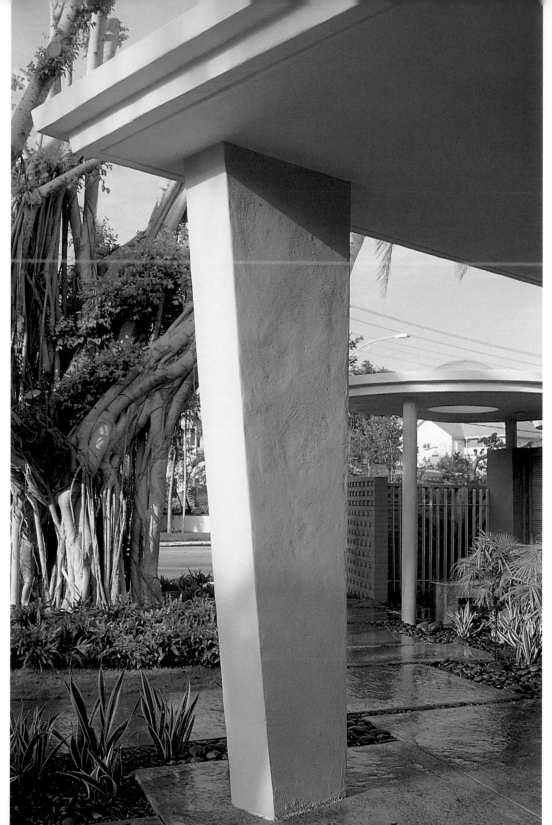

RIGHT: *View of the gateway through the new carport. The architectural elements harmonize with the massive Cuban laurel,* Ficus nitida, *in the foreground. This tree was toppled by Hurricane Georges in September 1998 and righted the week after the storm.*

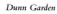

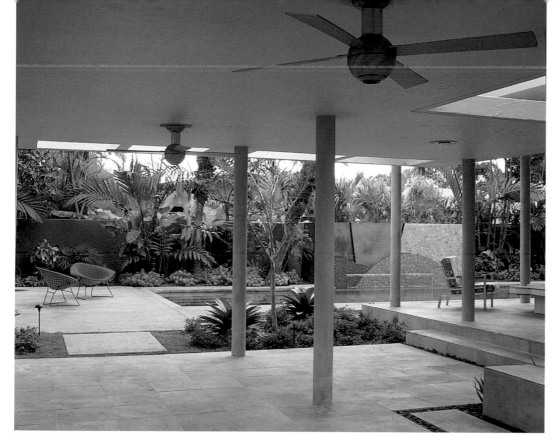

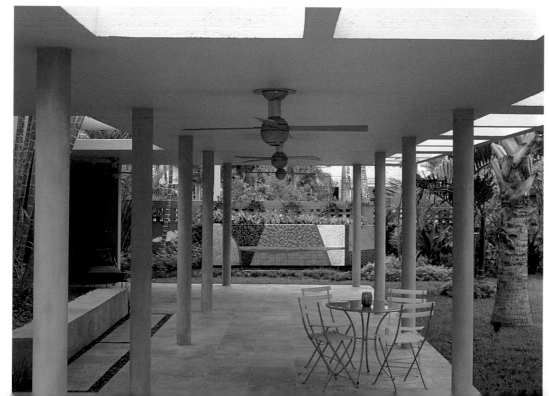

TOP: *View of the pool area. The pool deck is constructed of concrete slabs with a patina finish. Pavement in the existing loggia and new lanai is a rosa travertine. The ceramic mural is by Debra Yates.*

LEFT: *View through the loggia to one of the fountain murals. The pavement was widened to make the loggia more functional and a new bench added to provide additional seating.*

FOLLOWING PAGES: *Ceramic murals by Yates. The fountains were designed to draw the eye through the space, enliven fixed views, and filter noise from the adjacent road.*

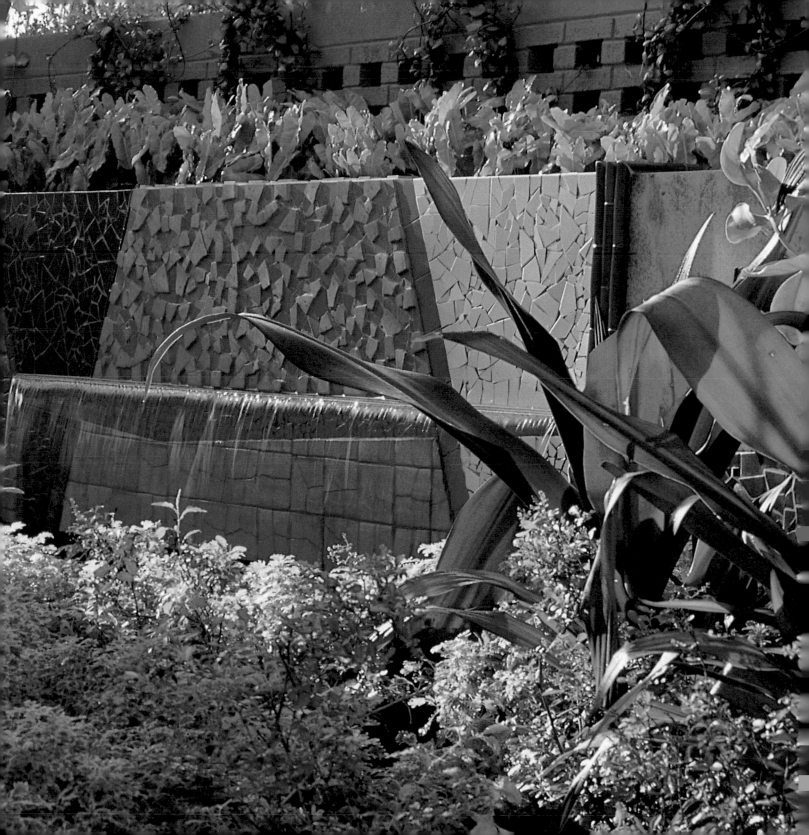

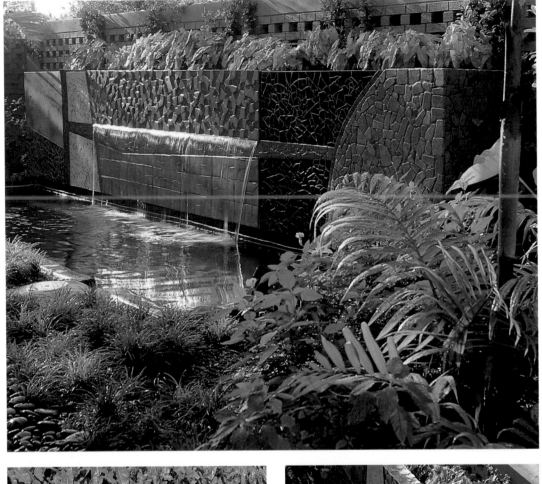

ABOVE: *This ceramic fountain mural by Debra Yates is 24 feet long by 4 feet high.*

LEFT: *Detail of the fountain mural at the loggia terminus.*

RIGHT: *A single design element functions as pool, mural, fountain, planter, and wall.*

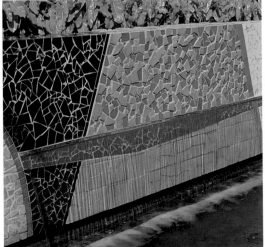

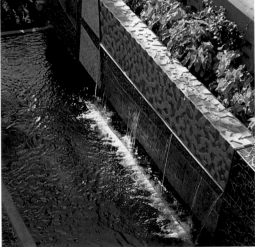

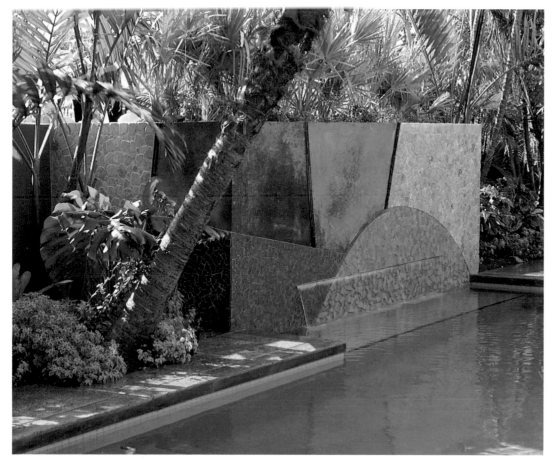

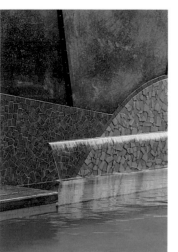

ABOVE: *The fountain/mural/planter at the pool features softer, more organic shapes and colors than the other two fountain murals. Planted above are* Serenoa repens 'cinerea,' *silver saw palmetto, a native. These palms add four feet of screening height along the rear property line.*

LEFT: *Detail of fountain.*

RIGHT: *Detail of swimming pool.*

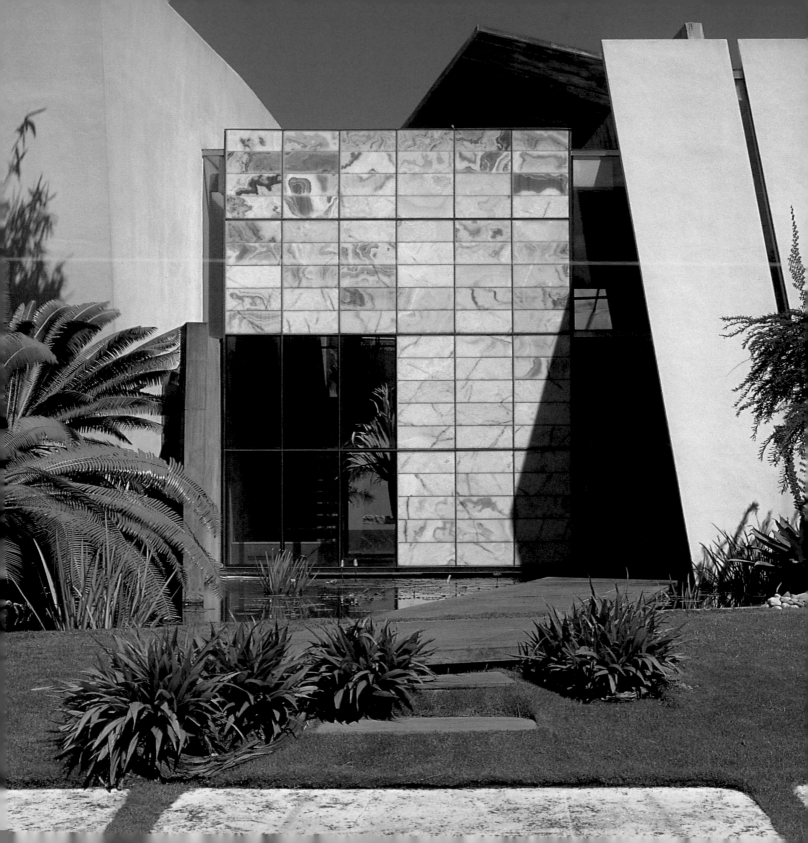

LANDES GARDEN

Golden Beach, Florida

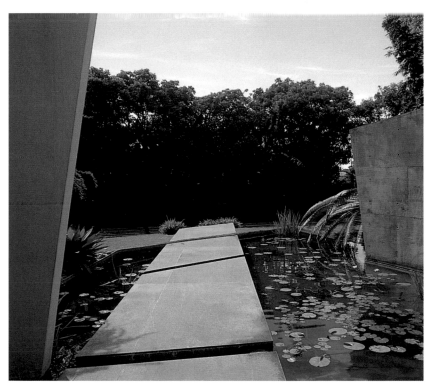

The sculptural statement of Carlos Zapata's architecture and the privacy-with-a-view demands of the ocean-front site created unique challenges for Jungles on this project. In addition, the owner, a renowned interior designer, wanted a natural, low maintenance beach garden that appeared "thrown", bold yet soft.

"For a romantic modernist like myself," says Jungles, "this project was a dream come true."

Jungles created dense plantings along three sides of the perimeter of the property with native plants, bamboo, and flowering shrubs. The view to the ocean was enhanced by a pool with a negative edge that appears to spill over into the Atlantic. The "thrown" look was accomplished with plantings of native, front line vegetation including sea oats, panic grass, silver agave, spider lily, and seagrape.

Single specimen plantings, such as a *Dioon spinulosum*, become sculptural entities that help balance the powerful architecture. Rubber molds of keystone were used to fabricate the concrete panels for the auto court, complementing the natural feeling of the garden.

ABOVE: *View from the front door. The floating walkway over the water garden was inspired by the works of Roberto Burle Marx. The dense planting in the distance screens the street.*
OPPOSITE PAGE: *View across the walkway to the front door. The rectilinear pattern of the golden onyx wall is repeated in the floating panels of the auto court. The Cycads on the left are* Dioon spinulosum *from Mexico.*

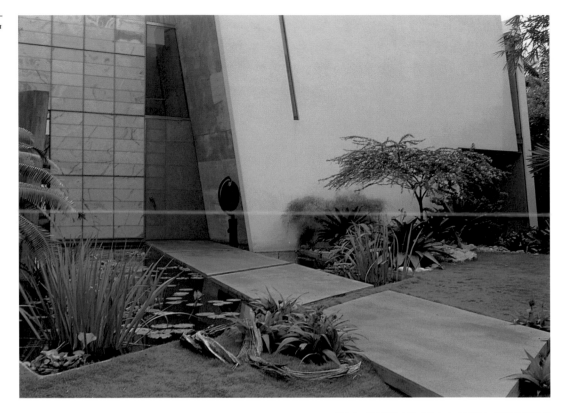

ABOVE: *The client requested that the the garden appear "thrown," or casual and natural. Driftwood and pebbles both contrast with and complement the sophisticated architecture. The small, light-green, yellow-flowering tree is* Senna polyphylla, *dessert cassia, from Puerto Rico/Hispanola.*
RIGHT: *The garden plan with the Atlantic Ocean to the right.*

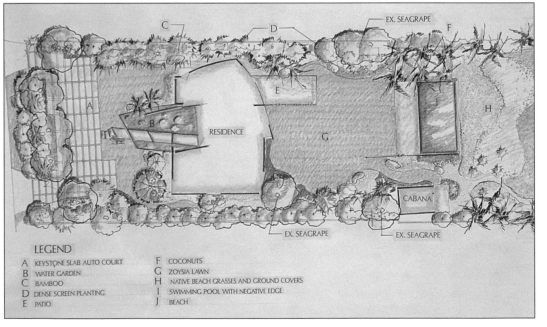

LEGEND
A KEYSTONE SLAB AUTO COURT
B WATER GARDEN
C BAMBOO
D DENSE SCREEN PLANTING
E PATIO
F COCONUTS
G ZOYSIA LAWN
H NATIVE BEACH GRASSES AND GROUND COVERS
I SWIMMING POOL WITH NEGATIVE EDGE
J BEACH

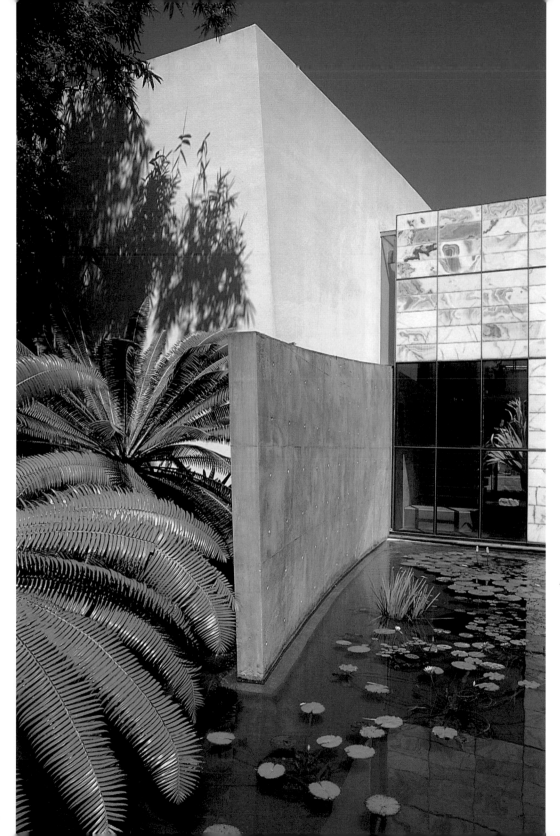

LEFT: *The bold texture and form of the* Dioon spinulosum *(foreground) complement the strong forms and volumes of the architecture. Shadows from the* Bambusa vulgaris *play on the two-story wall. The garden hardscape elements were a collaboration among Zapata, Catalina Landes, and Jungles.*

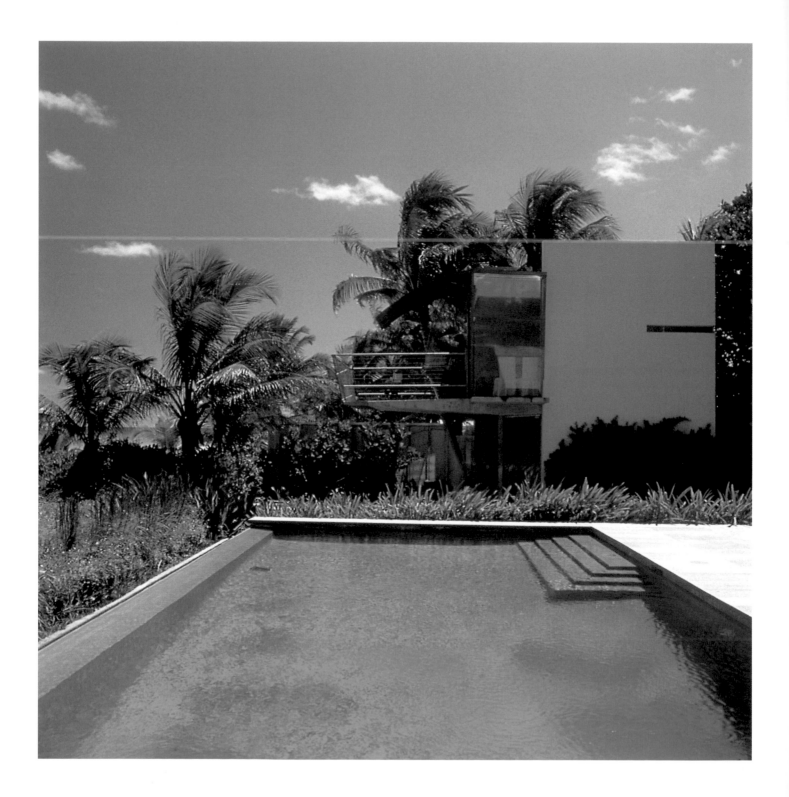

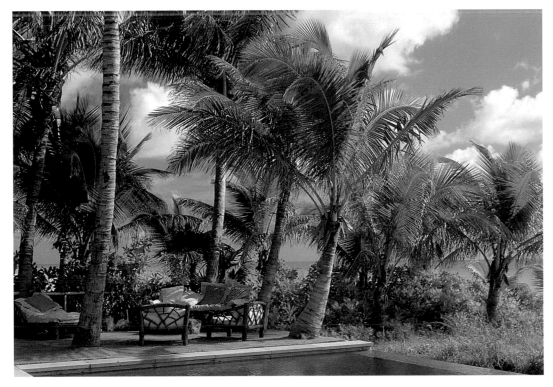

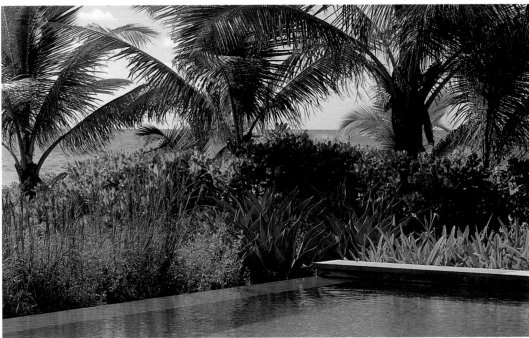

ABOVE: *View of the green terrace at poolside. Sometimes a tarpaulin is hung from the coconut palms above the bamboo furniture for shade.*

LEFT: *Native, hardy beach plants were added as a foreground element and to create a screen from the adjacent public beach.*

OPPOSITE PAGE: *View across the pool toward Zapata's casita.*

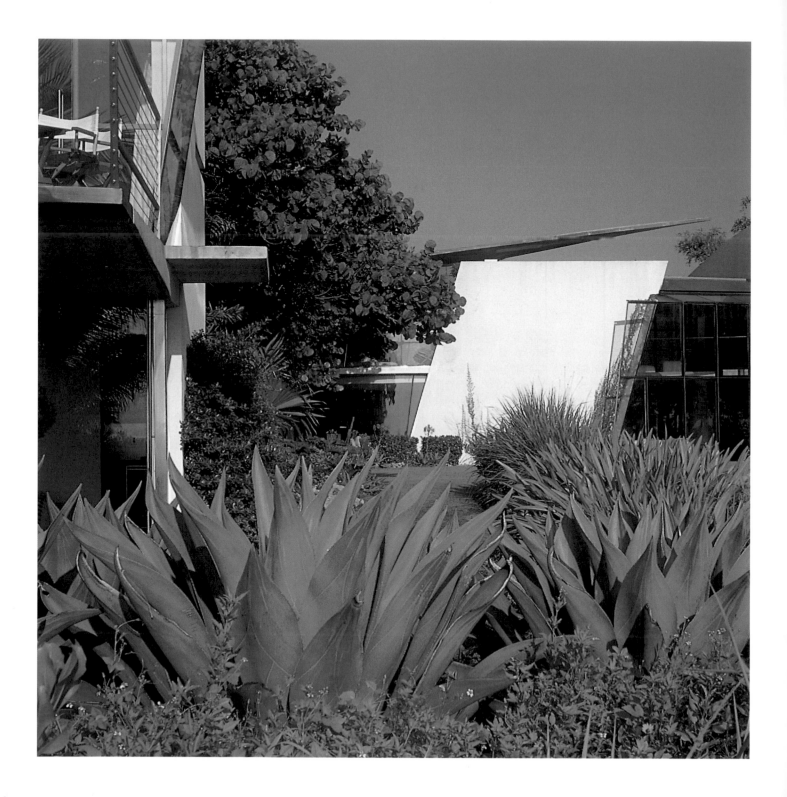

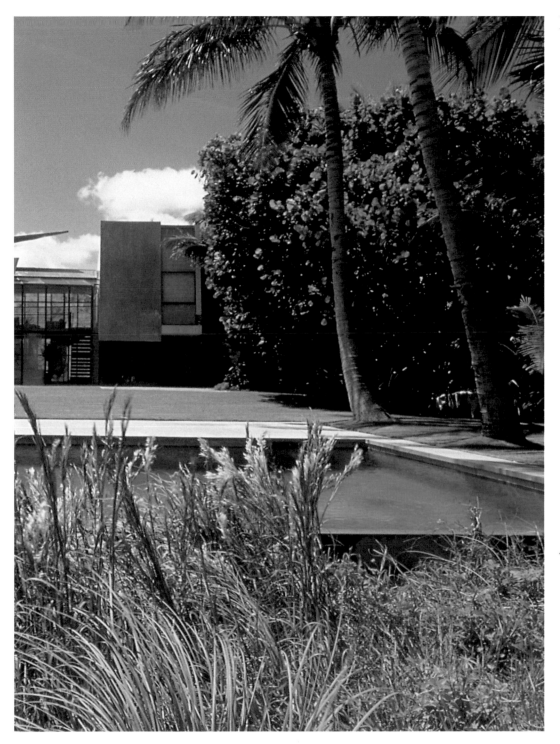

LEFT: *The pool was elevated to the same plane as the floor of the residence and the new zoysia lawn. The large leafy trees are* Coccoloba uvifera.
OPPOSITE PAGE: *View over a colony of silver agave to the main house.*

FOLLOWING PAGES: *View of the casita with the main house in the background. The beach grass is* Uniola paniculata.

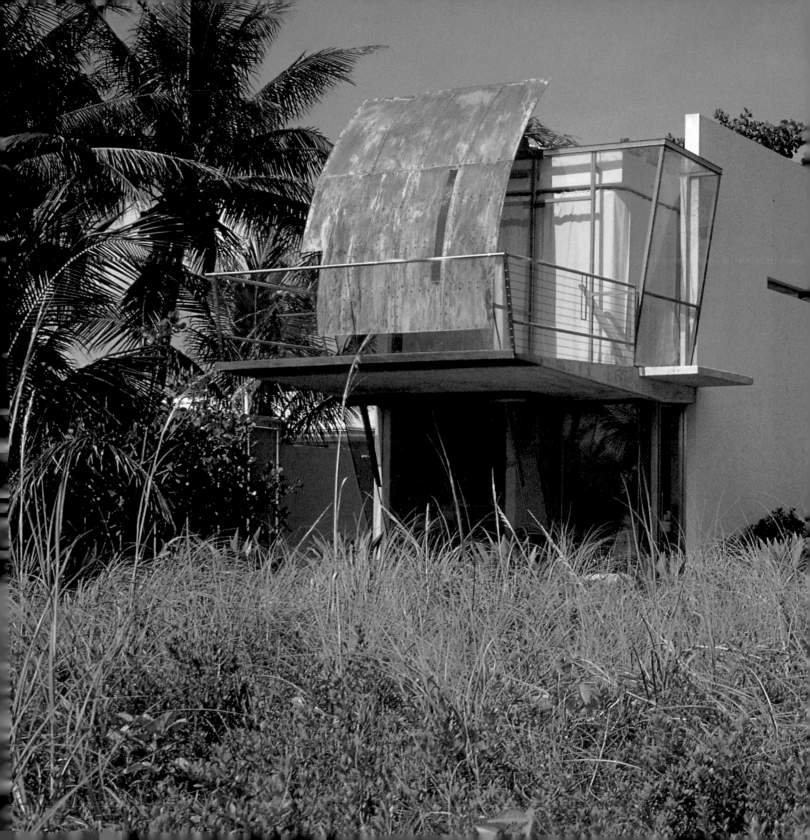

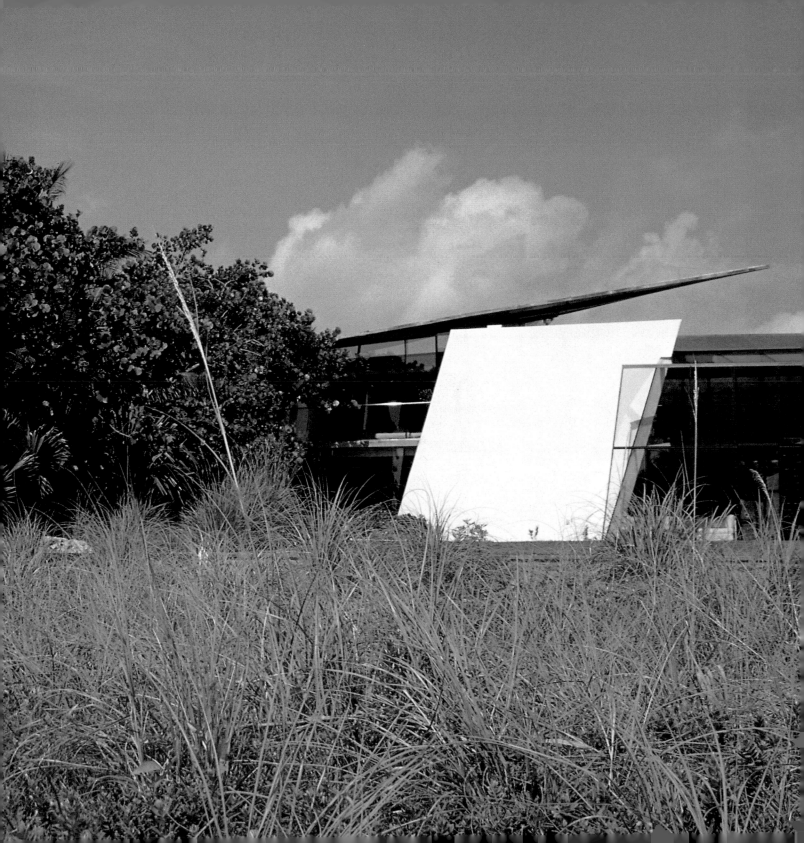

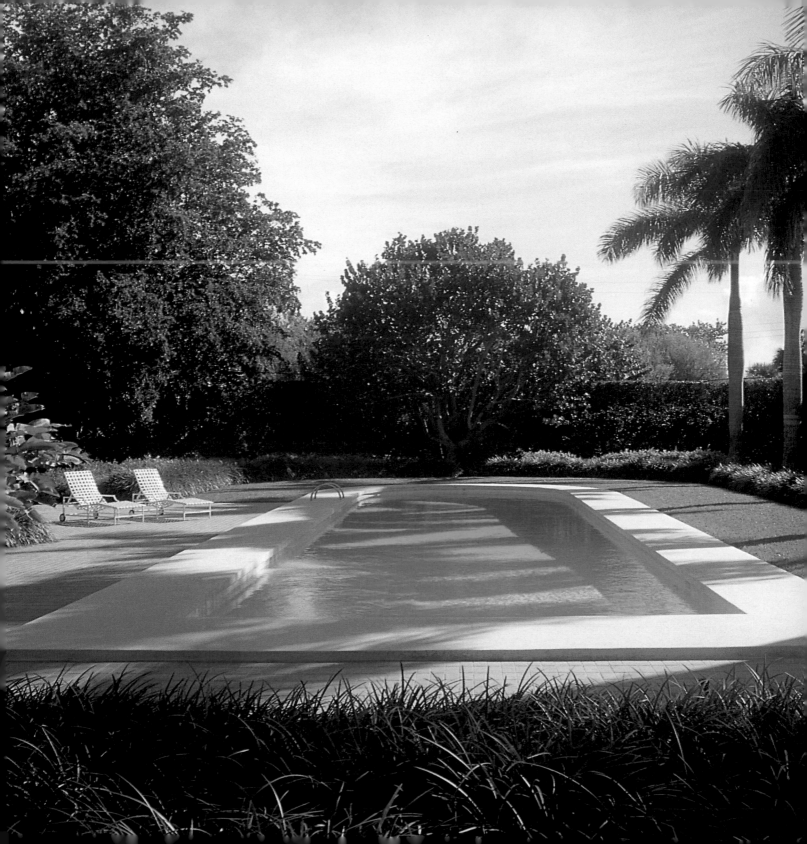

LORES GARDEN

Coral Gables, Florida

Jungles' early idealism was challenged by the stark rectangle of a typical South Florida backyard, utilitarian pool, views of telephone wires and little privacy. Out front, a circular drive, another common problem, completed the conundrum. The original Lores garden contained all of these elements.

"The generous size of the property and the simple, formal design of the house suggested bold, large scale solutions," Jungles says. "An existing tall, formal hedge was extended to offset a row of introduced majestic royal palms. This provides both privacy and perspective for a simple but elegantly shaped pool."

Platforms descending from the house to the pool and a tapis verde aligned with the lanai link the outside space dramatically to the house. What was once a backyard that looked like it belonged in a row of backyards, is now a unique, formal and private space open to the quiet drama of the sky. "We don't have the drama of mountains in South Florida, we have clouds," says Jungles.

The circular drive was replaced with an auto court, paved in large concrete slabs finished with a rock salt texture. A single live oak is now the focus of the space, inviting you into the house and garden.

ABOVE: *View of the lanai. Paved areas are treated as platforms that float gently down to the pool level.*

RIGHT: *All of the elements proposed in the garden plan were implemented with the exception of the fountain at the entrance platform and the two pergolas adjacent to the pool house.*

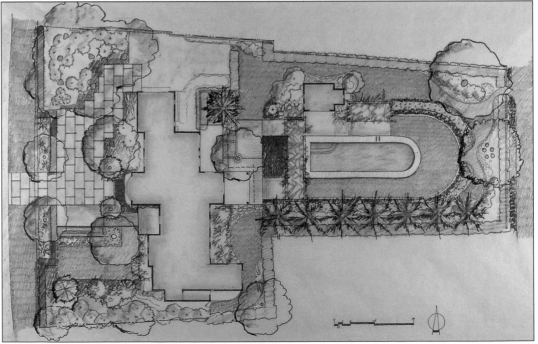

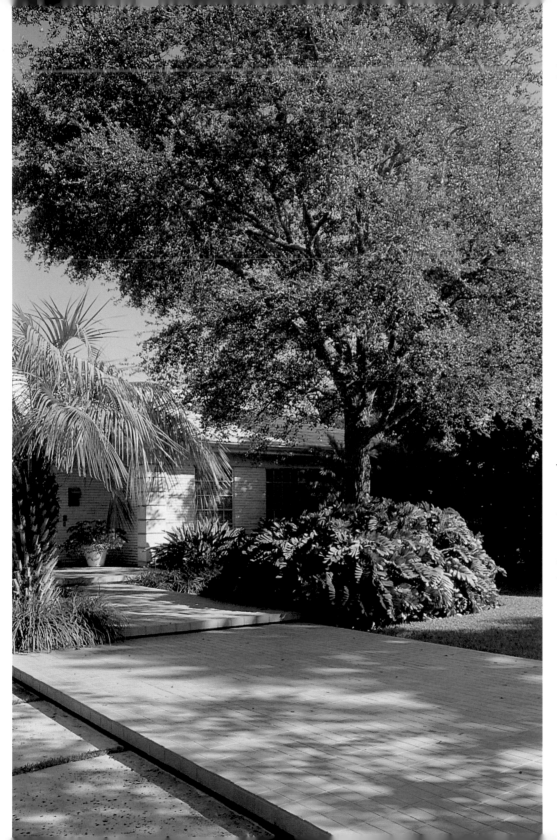

LEFT: *View of the entry walk platforms leading to the front door. The mature live oak was planted to balance existing live oaks elsewhere on the property. The mass planting at the base of the oak is* Zamia furfuracea, *cardboard palm, from Mexico. The palm on the left is* Butia capitata, *pindo palm, from Brazil.*

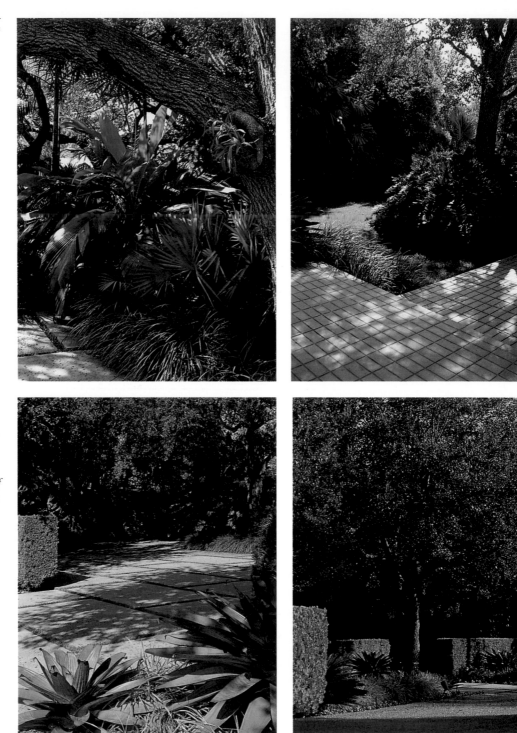

ABOVE: *(Left) The existing live oak grove was planted with understory palms including* Astrocaryum mexicana, *from Central America, native* Serenoa repens, *and* Licuala grandis, *from New Britian Island, north of Australia. (Right) View from the patio at the front door. The pavement pattern reverses at each level change.*
LEFT: *The auto court entrance.*
RIGHT: *Formal hedges of Podocarpus contain the front garden.*

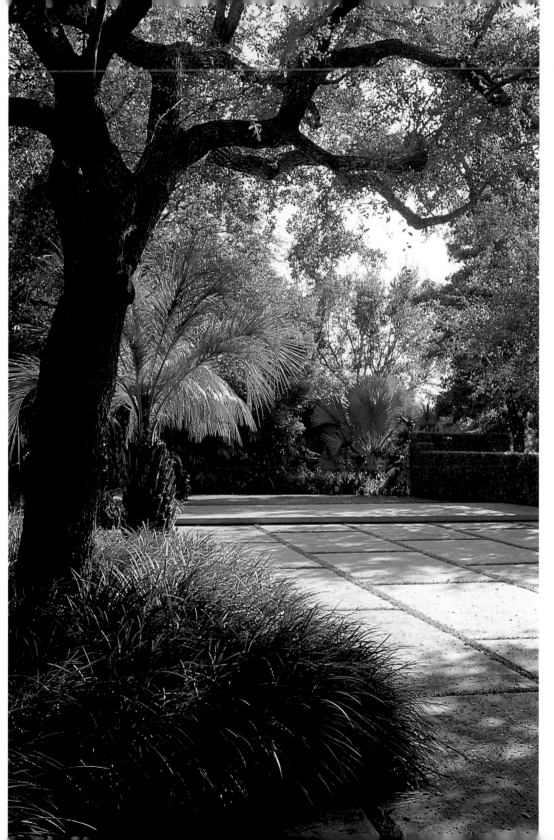

LEFT: *View of the auto court and entry walkway. The silver palm in the far corner is* Bismarckia nobilis, *Bismark palm, from Madagascar.*

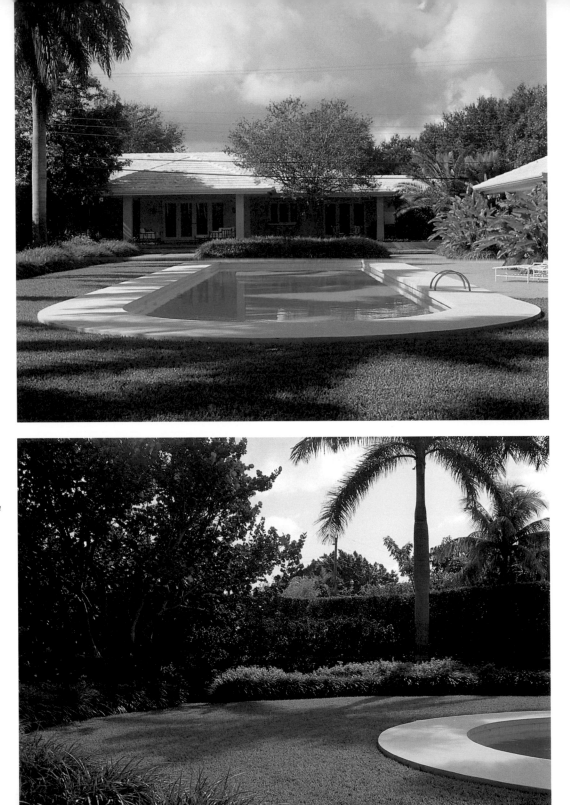

ABOVE: *View across the pool to the lanai and screened porch.*

RIGHT: *The geometry of the pool is repeated in the lawn and adjacent plantings.* Liriope muscari *'Evergreen Giant*

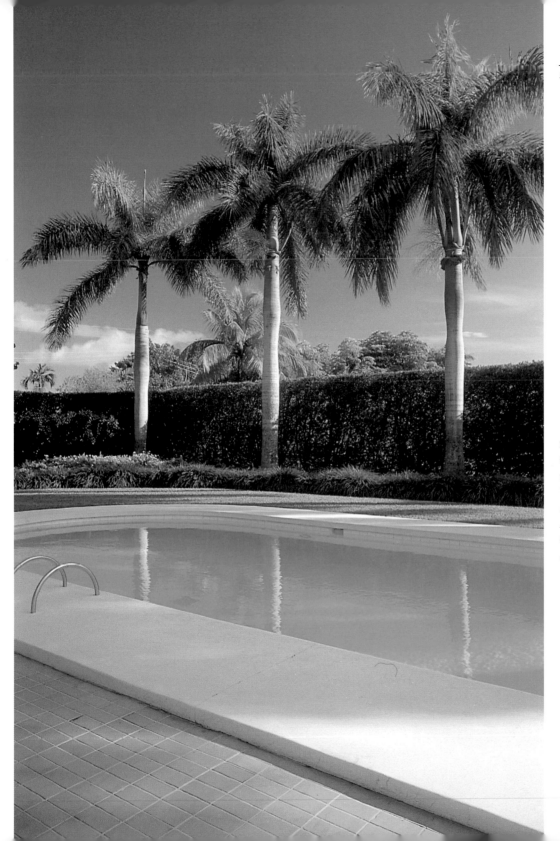

LEFT: *View from the pool deck. The wide coping around the pool is a bold visual image and allows easy access. The custom-made handrail of the ladder echoes the shape of the pool. An existing tall hedge of native* Chrysobalanus icaco, *cocoplum, was extended and filled in.*

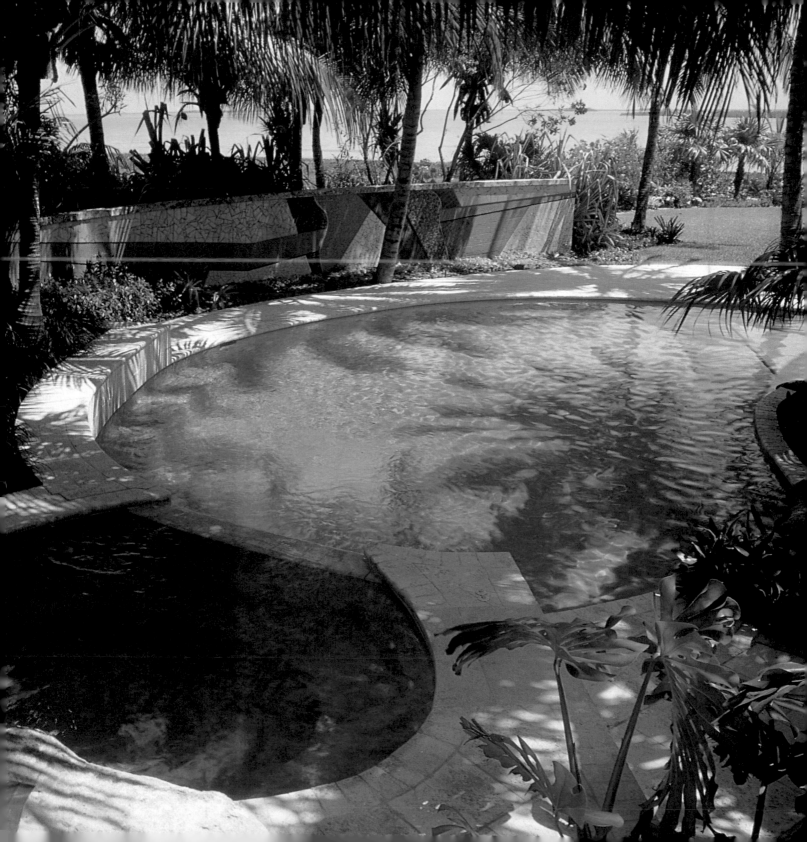

SALINERO GARDEN

Lower Florida Keys

ABOVE: *A* Clulsia rosea, *autograph tree, enlivens distant views.*
OPPOSITE PAGE: *View from the pool overlook on the walkway to the front door. A dramatic 60-foot ceramic mural by Debra Yates underlines the vista of Florida Bay.*

A Jungles garden is a miniature ecosystem that enhances native flora and develops existing topography. This project began devoid of both, as a flat, rocky site barren of vegetation, overlooking a bay with winds of 30 miles per hour, and months of drought.

"It is unusual to visit a site and go back to the drafting board with little more than the blank paper itself," says Jungles. "But it gave me freedom to address the unique desires of the client."

One of the clients uses a wheelchair and said, "I wanted the garden to be all jungle, but an organized jungle. And of course I wanted it accessible, including the pool, without looking 'handicapped'." The garden also needed to be self-sustaining with low maintenance.

Jungles based his design on curvilinear forms that organically flow around the house, as if carved by the wind and sea. A rock fountain spills into the spa which in turn flows into a gourd-shaped pool accessible by a gentle, disappearing ramp. A 60 foot tile mural, designed by Debra Yates, mixes an exotic rhythm of colors such as cobalt, turquoise, and lavender with lush and fragrant plantings of allspice trees, golden Hawaiian bamboo, triangle palms, and elephant ear alocasias. This jungle-on-request, which is drought and wind resistant, has attracted its own population of birds. "We've got one heron that's in love with our pool," according to the client.

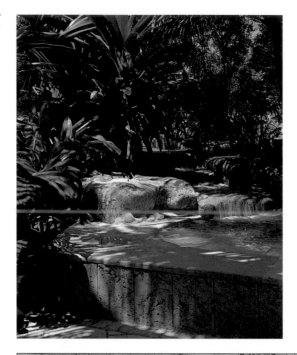

ABOVE: *Detail of the bubbling spring-like fountain as it spills into the spa. While it is not visible from the walk-way, the sound of the water invites one to explore the garden.*
RIGHT: *The garden plan. Soft curves are prominent.*

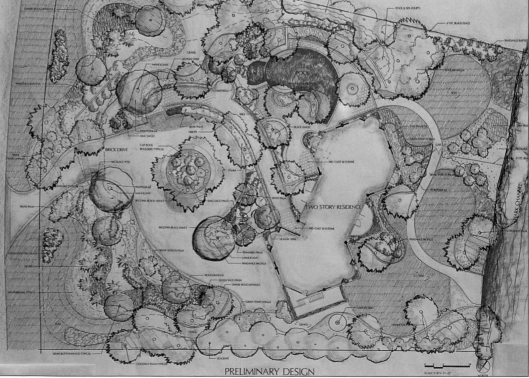

PRELIMINARY DESIGN

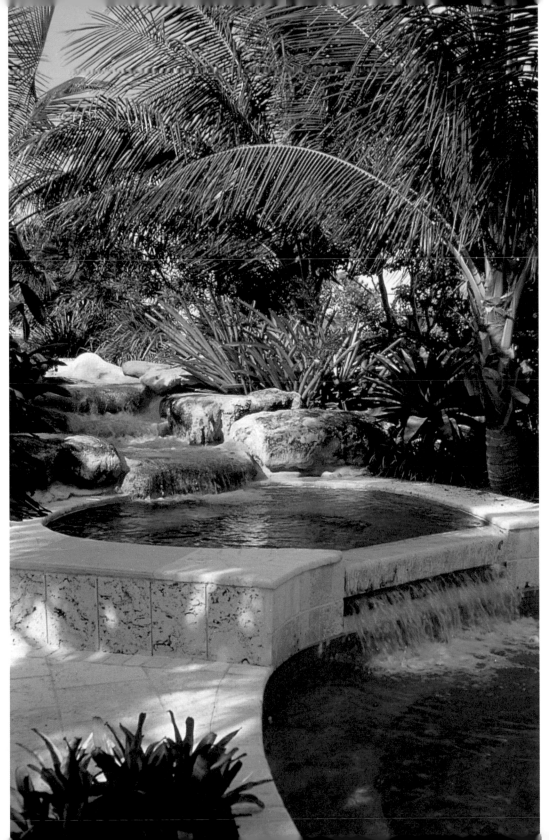

LEFT: *The elevated seat ledge of the spa permits easy transfer from a wheelchair. At the request of the clients, most of the pool garden is shaded.*

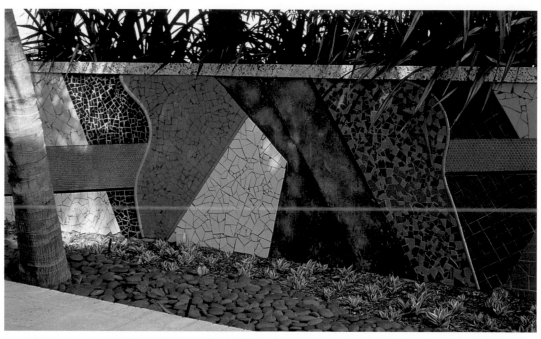

ABOVE: *Detail of the pool's edge.
(Right)* Sansevieria trifasciata
*'Dwarf gold Hahnii' brings some of
the mural's color into the garden. The
bed of black Mexican river rock adds
drama and is easy to maintain.*
RIGHT: *View of the pool overlook from
the walkway to the front door. The tree
on the right is* Pimenta dioica, *all-
spice. The planters along the walkway
contain Bromeliads, desert rose, and
dwarf natal plum, all plants with low
water requirements.*

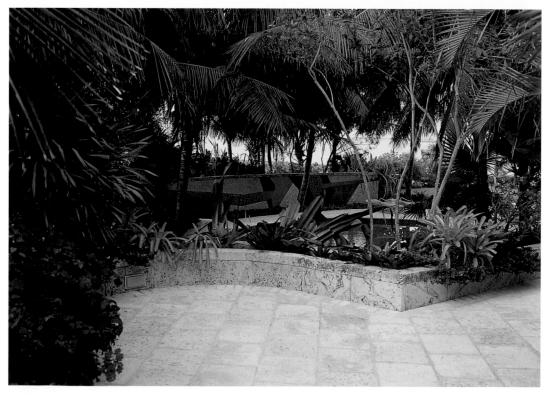

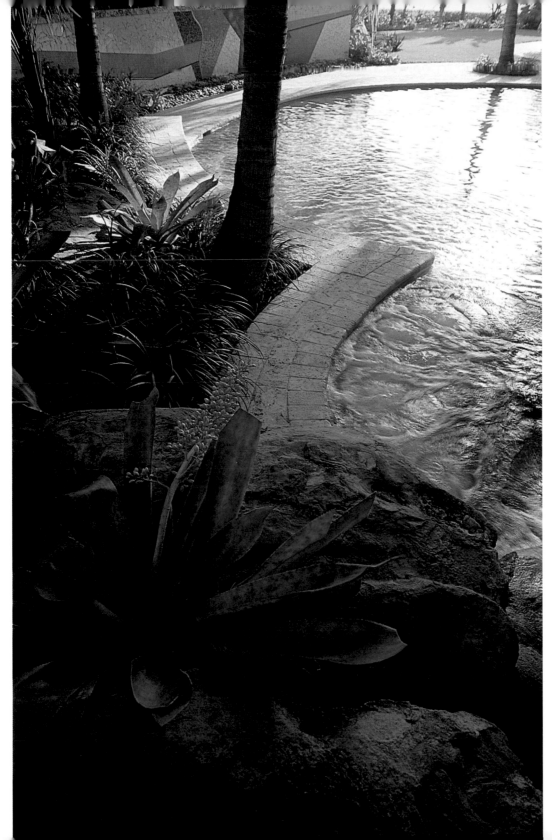

LEFT: *View from the pool overlook. The large-leaf plant in front is* Aechmea mexicana, *from the island of Fiji. The pool finish is a double-silver grey marsite*

ABOVE: *(Left) View of the walkway to the auto court from the cutting garden. (Right) The auto court. Parking is provided under the residence beyond the* Pandanus utilis, *screw pine, in the center.*

RIGHT: *View of the ramped entry walkway to the auto court. The numerous defined spaces within the garden flow seamlessly together.*

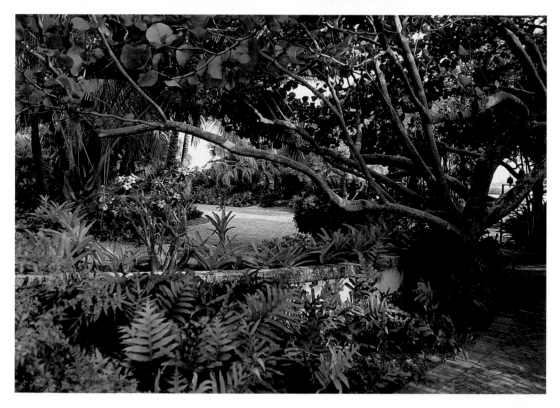

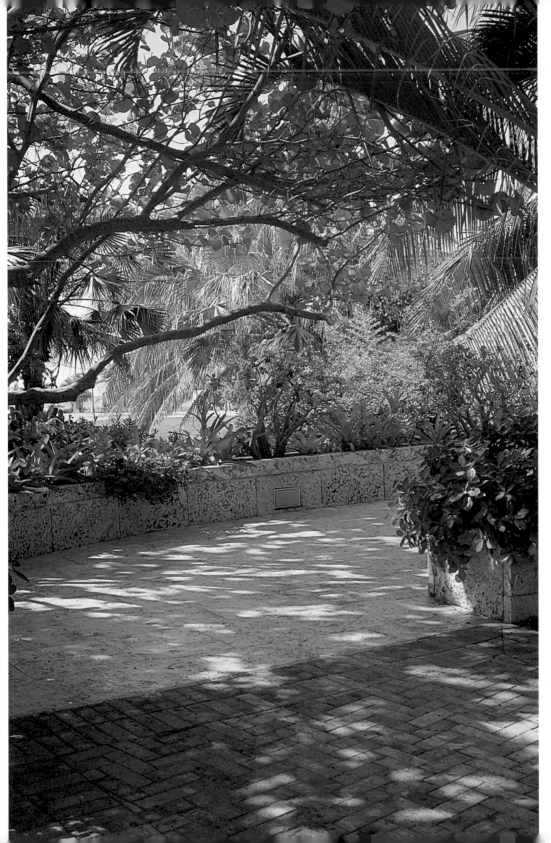

LEFT: *The ramped walkway leading to the front door. A seagrape tree provides an inviting overhanging threshold.*

YOUNG GARDEN

Miami, Florida

Jungles blurs the line between the modern and the romantic as this garden entices you from the interior to the exterior and back again.

"Burle Marx designed much of his work like musical composition, with harmony interrupted by elements of surprise," Jungles recalls of his mentor. "This garden is a good example of my own use of contrapuntal tones. A long, linear wall, for example, terminating with the sky-burst fronds of a Bismarckia rising out of a wild bed of fakahatchee grass."

Orderly orthogonal shapes in the hardscape mimic the footprint of the house, creating a harmony that Jungles then ruffles with triangle, sabal, and veitchia palms.

A sculptural musical fountain adds to the allusion, a vibraphone of water arcing over the heads of swimmers seated on an underwater ledge. "When the sun strikes the bars of water," says one of the owners, "the effect is sensational. We couldn't afford a home on the ocean so Raymond brought the ocean to us."

ABOVE: *View of the service/garage entry. The existing large, circular asphalt driveway was removed and automobile parking was relegated to unobtrusive locations.*
OPPOSITE PAGE: *View of the entrance to the visitor's auto court. Parking is under the seagrape tree on the right.* Bismarckia nobilis, *Bismarck palms,* and Bougainvillea *spp. 'Easter Parade' line the low wall that defines the street side of the property.*

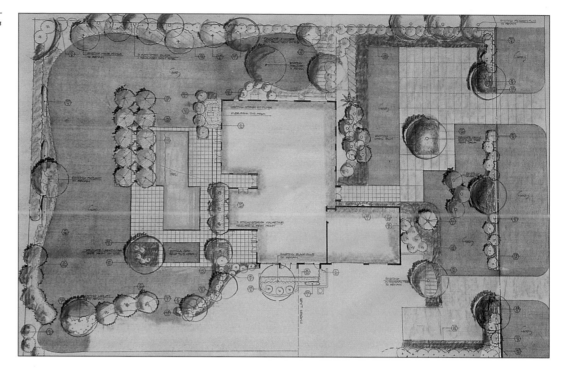

ABOVE: *The garden plan.*

RIGHT: *A variegated coral tree is centered in the courtyard that separates the guest parking area from the entrance walkway. Identical paving material unifies the walkways and the parking areas.*

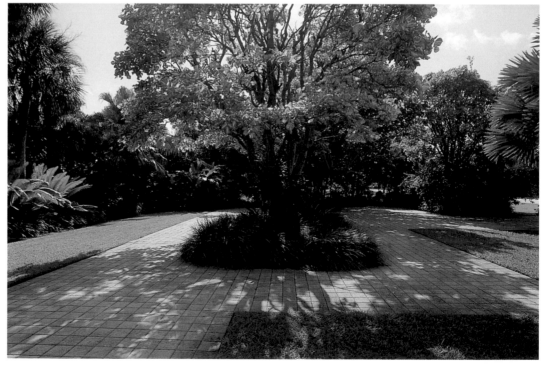

ABOVE: *View of the courtyard tree and entry walkway. The two palms in the lawn are* Sabal palmetto, *sabal palm, the Florida state tree.*

LEFT: *Bromeliads were installed at eye level in the variegated coral tree, a common feature in Jungles' gardens. The Cycads on the left are* Dioon spinulosum, *from Central America.*

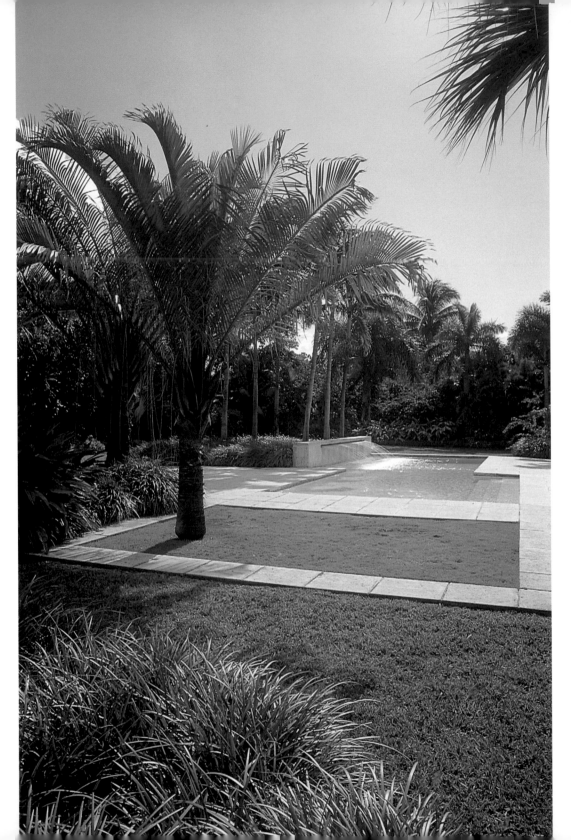

RIGHT: *View of the pool garden from the north. The zoysia grass extends the area around the pool for entertaining.*

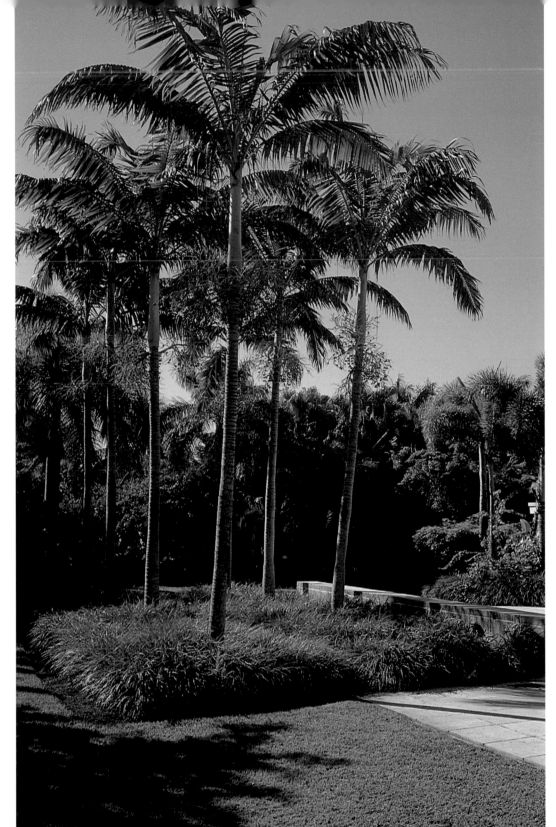

 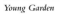

LEFT: *A grouping of* Veitchia montgomeryana *flanks the fountain wall of the pool.*

FOLLOWING PAGES: *(Left)* Dypsis decaryi, *triangle palms from Madagascar, create a dramatic background for the pool and deck. (Right) A continuous seat ledge at the base of the fountain wall is a cool spot on a hot Florida day. Custom-made precast concrete pavers form the pool coping and the fountain wall.*

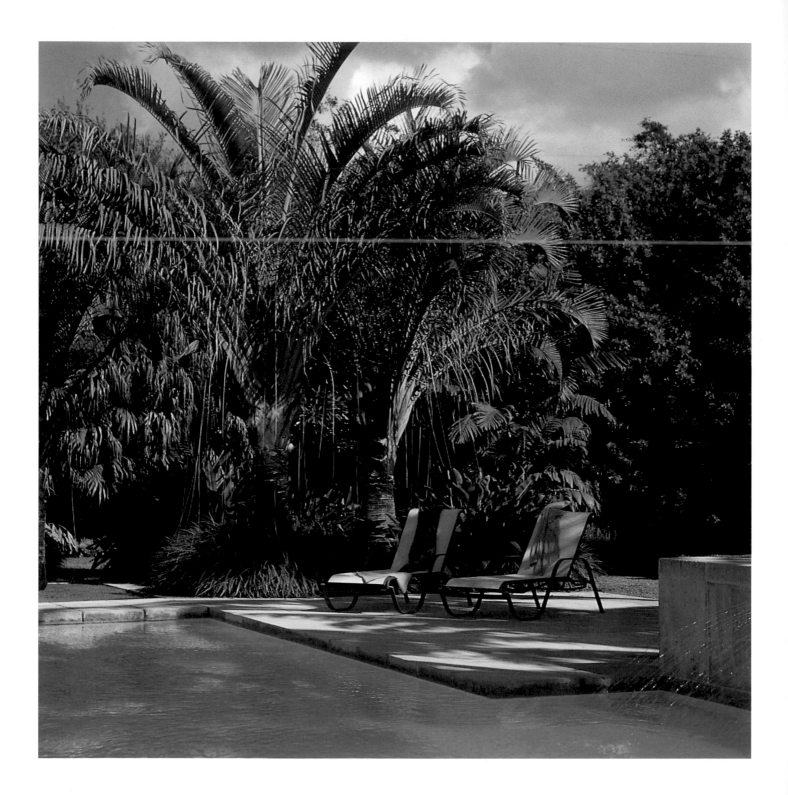

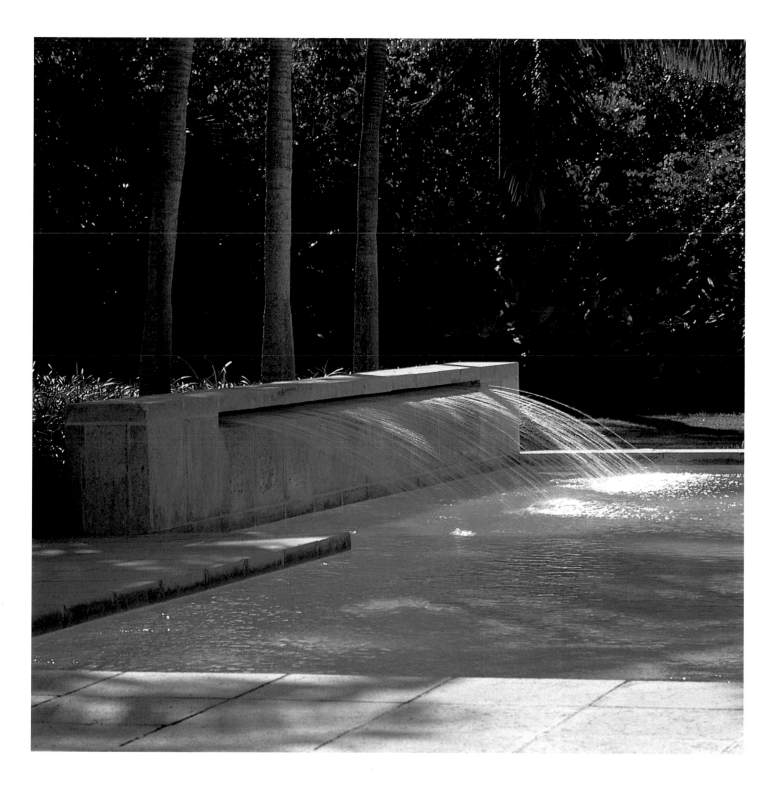

JUNGLES/YATES GARDEN

Key West, Florida

ABOVE: *View of the masonry walls and louvered fence enclosing the garden's private spaces. The palm in the middle-ground is* Pseudophoenix vinifera, *wine palm from Haiti.* OPPOSITE PAGE: *The vertical mass of the chimney was the inspiration for the tall monolithic ochre walls.*

This property has been in the Yates family for almost sixty years. The house was originally constructed by Debra Yates' father in the late 1940's from a floor plan he saw in an issue of *Better Homes and Garden* magazine. The renovation of the house and gardens surrounding it has been ongoing for the last four years.

"The problem with a labor of love," Jungles says, "is that it never ends. We have gone through three phases of renovation and redesign. Then in 1998, Hurricane Georges hit Key West pretty hard and we had to do a lot of replanting. When I look around I always see things I want to do. This is really my laboratory, where I can experiment with rare species and unusual compositions. It's a living work of art that I change constantly."

In no other Jungles design is Roberto Burle Marx's influence so prominent. One of his rare ceramic tile murals graces the pool, and plant materials native to Brazil are everywhere, many of them coming directly from Marx's garden. Twelve foot sculptural walls, painted in purples and pinks reminiscent of Luis Barragan, shoot through a canopy of palms and Tropical Almond trees.

A unique type of paving stone left over from a previous job creates a secret path of muted orange. A five-foot tall terra cotta amphora draws the eye across the auto/basketball court constructed of jade green slabs of concrete and with a border of black volcanic rock.

"There are many reasons why people walk into a garden and say, 'Ah, this feels so good,' says Jungles. "When I walk into mine I want the same feeling, although I'm always thinking about what I'm going to try next. I'm a restless sensualist who loves to see things grow."

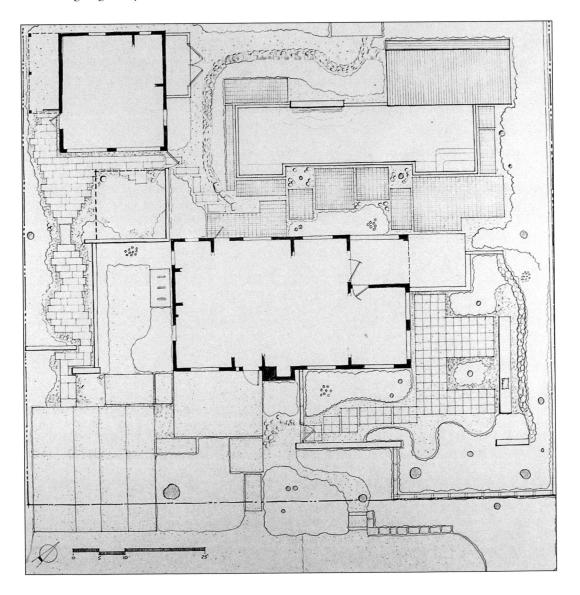

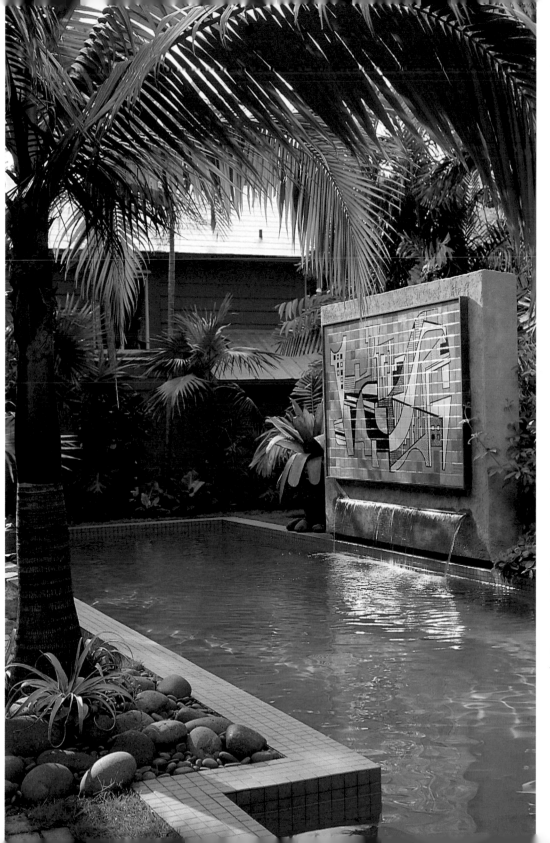

LEFT: *View across the pool to the ceramic mural by Roberto Burle Marx and Haruyoshi Ono. The palm to the left is* Satakentia liukiuensis, *from the Ryuku islands.*

OPPOSITE PAGE: *The evolving garden plan*

FOLLOWING PAGES: *(Left) The fountain wall with the Burle Marx mural. (Right) View across the pool to a silver palm,* Latania loddigesii, *planted by Jungles from a seed 10 years ago.*

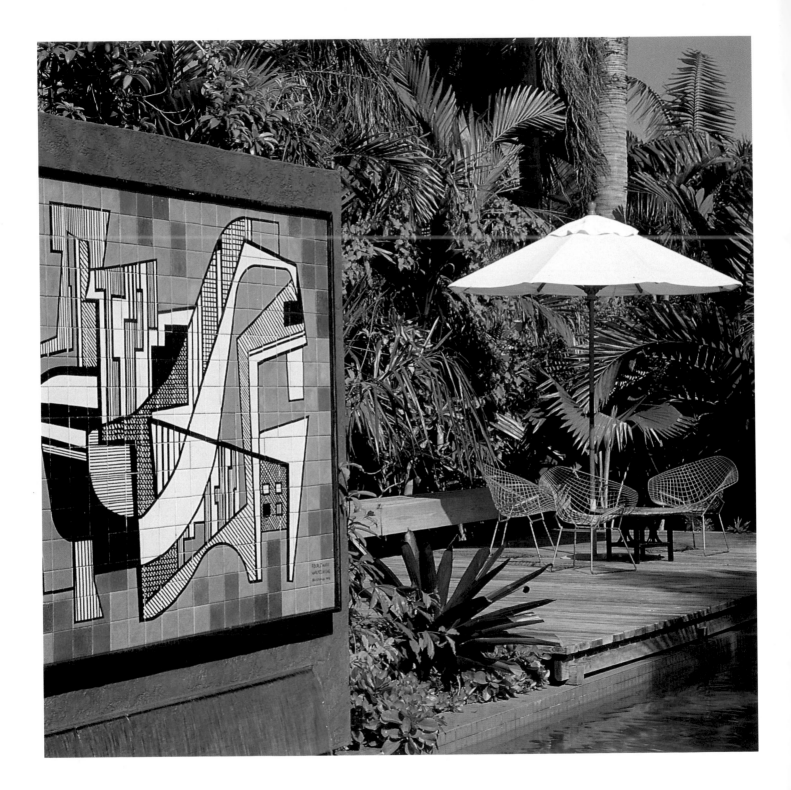

ABOVE: *Detail of the fence and masonry wall.*

LEFT: *The concrete patio and floating step have a rock salt texture and mineral patina finish.*

RIGHT: *View through the garden gate into the private garden.*

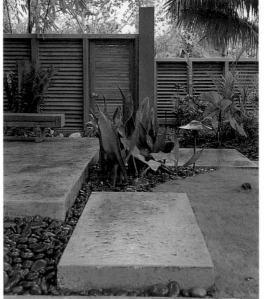

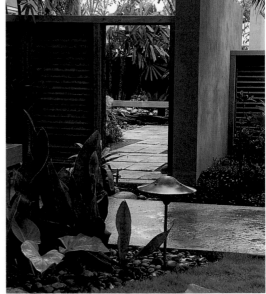

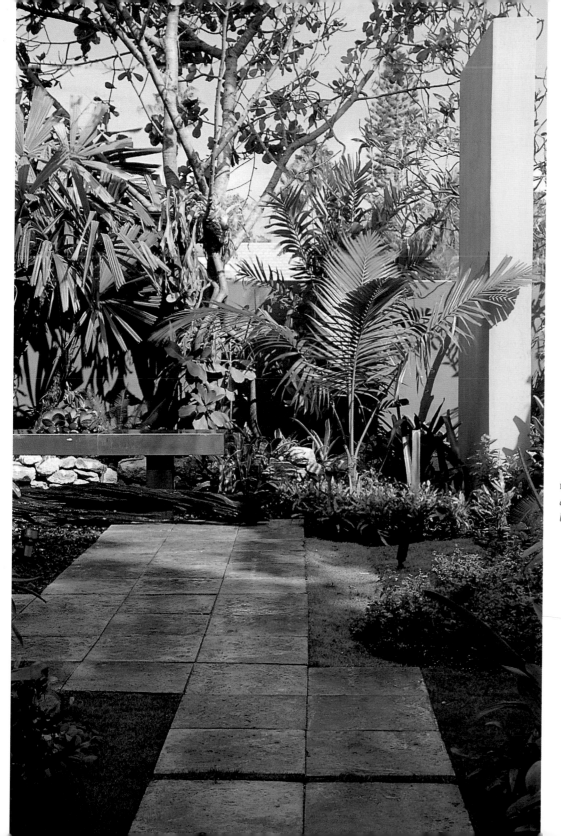

LEFT: *The monolithic wall floats poetically within the exterior space created by the new fences, walls, and plantings.*

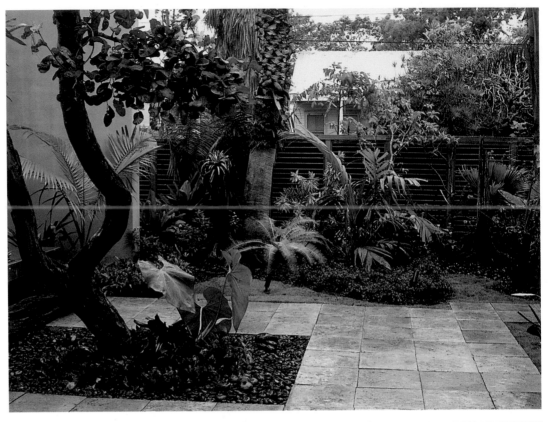

ABOVE: *The lower interior garden viewed from the pool area.*
LEFT: *The enclosed garden space in front of the cottage.*
RIGHT: *Detail of the wall and fence system designed to separate the cottage from the main house.*

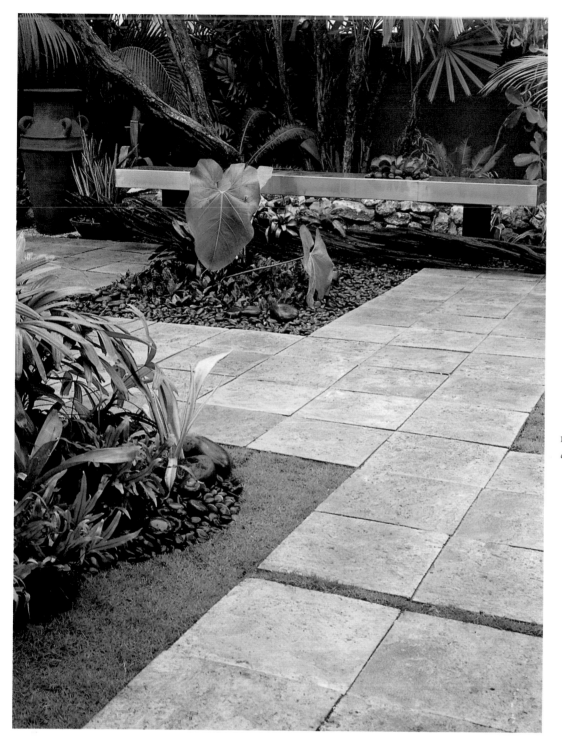

LEFT: *Detail of the lower garden with a stainless steel bench/work table.*

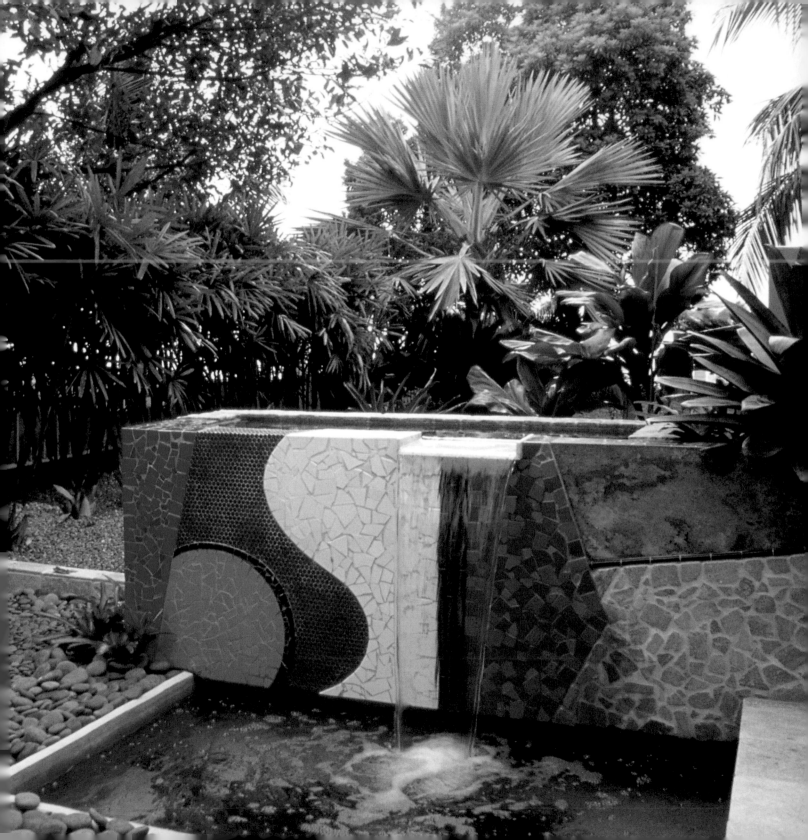

MARATHON GARDEN

Marathon Key, Florida

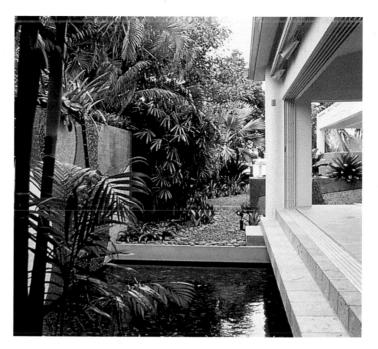

The owners of this Florida Keys property, a musician and an inventor, built an addition to their house to function as a creative work space. To complement the addition and provide visual and creative stimuli, they called upon Debra Yates to design a ceramic garden mural. Jungles' garden design actually ended up using two Yates mural walls that double as planters and water gardens, enlivening the small, potentially static space adjoining the addition.

"Like many landscape architects I love large scale projects but transforming a small, potentially static space is often more challenging," says Jungles. "Debra's designs for the murals—actually they're outdoor paintings—graphically expressed yin and yang. That inspired my design, making one water garden serene and one flowing and bubbling. I also used opposing textures and materials that work with each other like the strong colors in her murals."

The result is a compact garden with a waterfall, a connecting stream, a visually restful bed of black river rock, and a reflecting pool that pulls the sky into the garden, creating an engrossing visual experience from the owner's work space.

Native palms and cyads were used throughout the garden and require very low maintenance.

ABOVE: *The pavilion-like studio overlooks the fountain pool and the ceramic mural.*
OPPOSITE PAGE: *In the planter, the giant* Vriesia Imperialis *from Brazil has a sculptural form which complements the mural. The colorful* Cordyline *'Peter Buck' is vibrant against the silver* Latania lantaroides *from the Mascarene Islands.* Rhaphis excelsa, *lady palm, provides a loose palm hedge.*

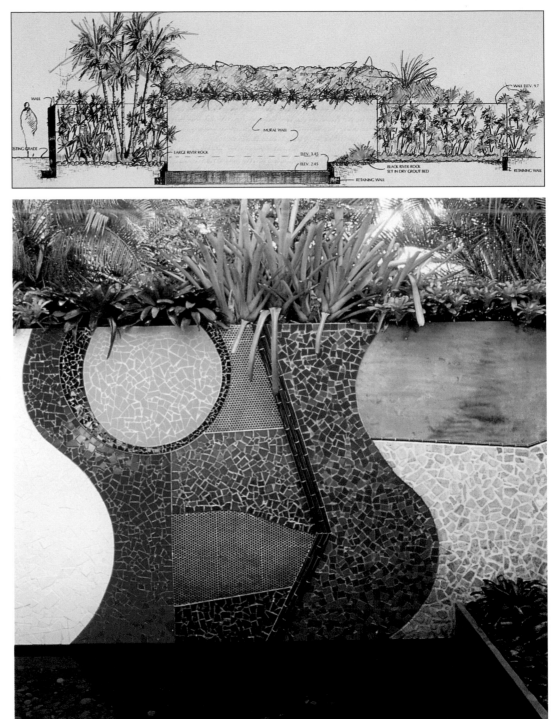

ABOVE: *Elevation drawing of the mural wall and section view through the reflection pool.*

RIGHT: *Neoregelia and Aechmea Bromeliads enliven the mural wall and provide additional privacy. A built-in planter provides drainage. Debra Yates' mural consists of different textures and colors of ceramic tiles, stone, and copper.*

OPPOSITE PAGE: *(Left) A view through the garden. (Right) A detail of the wall and reflecting pool.*

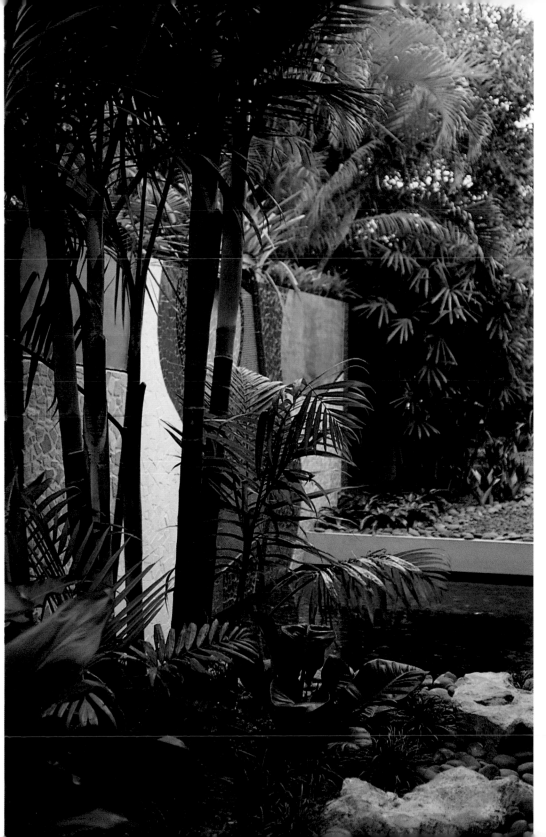

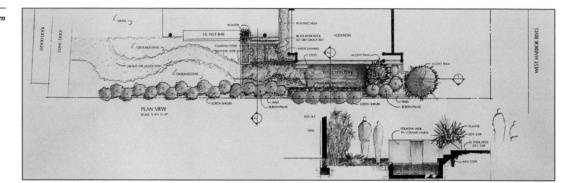

ABOVE: *This drawing shows the relationship of the studio addition to the small 12- by 50-foot garden. The large mural wall steps in from the property line allowing room for tall screen plants to buffer the adjacent residence.*

RIGHT: *When in bloom,* Neoregelia compacta Bromeliads *from Brazil have red rosettes that complement the tile in the mural.*

OPPOSITE PAGE: *(Left) The weir overflow is constructed of the same tile as used on the deck and the steps.*
(Right) Sheet flow fountains are a reoccurring element in Jungles' gardens.

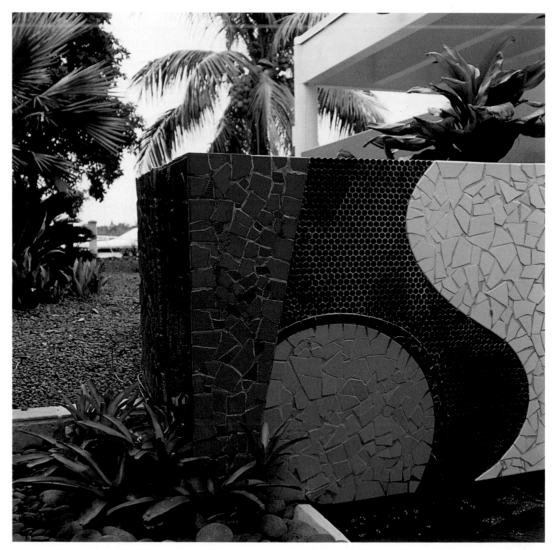

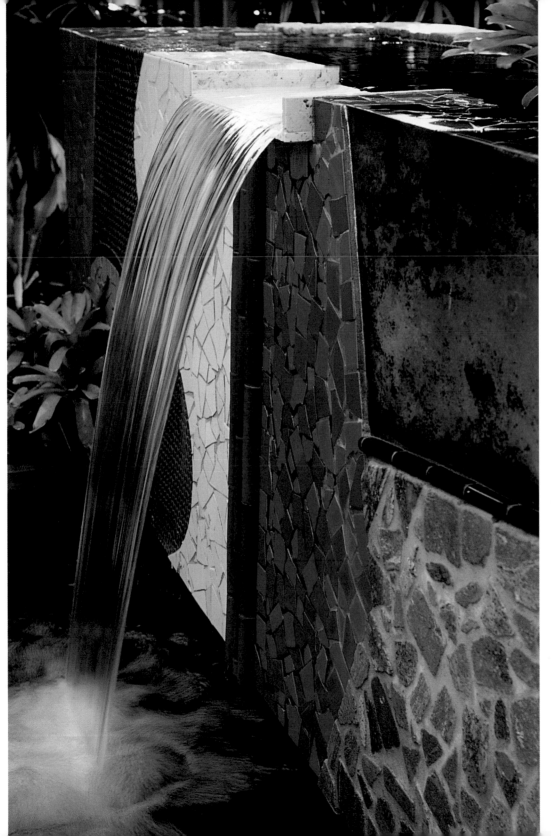

SELECTED GARDENS

Spanish Tropical Garden
Southern Florida

Site: 210- by 120-foot lot
Landscape contractor: Stan
Matthews, Plant Creations
Soils: sandy loam topsoil
over oolitic limestone
General contractor for pool
house and recreation pavil-
ion: Walter Daggett
Lighting: Kim and B-K fix-
tures; Perry Kuhn, lighting
consultant

Montifiore Garden
Miami Beach, Florida

Site: 120- by 240-foot lot
Landscape contractor: Stan
Matthews, Plant Creations
Soils: imported topsoil over
dredged fill
Lighting: Kim and B-K fix-
tures; Perry Kuhn, lighting
consultant

Sims Garden
Coral Gables, Florida

Site: 80- by 124-foot lot
General contractor: Action
Builders
Landscape contractor: Stan
Matthews, Plant Creations
Soils: organic topsoil over

oolitic limestone
Lighting: HADCO,
Lumiere, and Kim fixtures

Dunn Garden
Key West, Florida

Site: 160- by 100-foot lot
General contractor: Deal
Builders
Patina by Mineral Life, Inc.
Lighting consultant: Perry
Kuhn
Contractor for garden
structures: Howie Schneider
Landscape contractor: Stan
Matthews, Plant Creations
Soils: sandy loam topsoil
over Florida Keys limestone
Lighting: Kim and B-K fix-
tures
Mural artist: Debra Yates

Landes Garden
Golden Beach, Florida

Site: 100- by 400-foot lot
General contractor: Cruz
Rodrigez
Landscape contractor: Stan
Matthews, Plant Creations
Soils: sand, imported plant-
ing soil
Lighting: Dana Brown,
design and installation

Lores Garden
Coral Gables, Florida

Site: 200- by 300-foot lot
Landscape contractor:
Melrose Nursery and
Landscape
Patina by Mineral Life, Inc.
Soils: sandy loam topsoil
over oolitic limestone
Lighting: Kim fixtures

Salinero Garden
Lower Florida Keys

Site: 240- by 170-foot lot
General contractor: Salinero
Enterprises
Landscape contractor:
Manuel Diaz Farms
Soils: imported soils over
Florida Keys cap rock
Lighting: HADCO fixtures
Mural artist: Debra Yates

Young Garden
Miami, Florida

Site: 260- by 170-foot lot
Landscape contractor:
Nature's Way
Soils: sandy loam topsoil
over oolitic limestone
Lighting: low voltage

Jungles/Yates Garden
Key West, Florida

Site: 100- by 100-foot lot
Landscape contractor: Stan
Matthews, Plant Creations
Soils: sandy loam topsoil
and imported soils over
Florida Keys limestone
Lighting: B-K, Seagull, and
Kim fixtures; Perry Kuhn,
lighting consultant

Marathon Garden
Marathon Key, Florida

Site: 120- by 120-foot lot
General contractor:
Aultman Construction
Landscape contractor: Stan
Matthews, Plant Creations
Soils: imported topsoil over
dredged fill
Lighting: HADCO and Kim
fixtures; Perry Kuhn, light-
ing consultant
Mural artist: Debra Yates

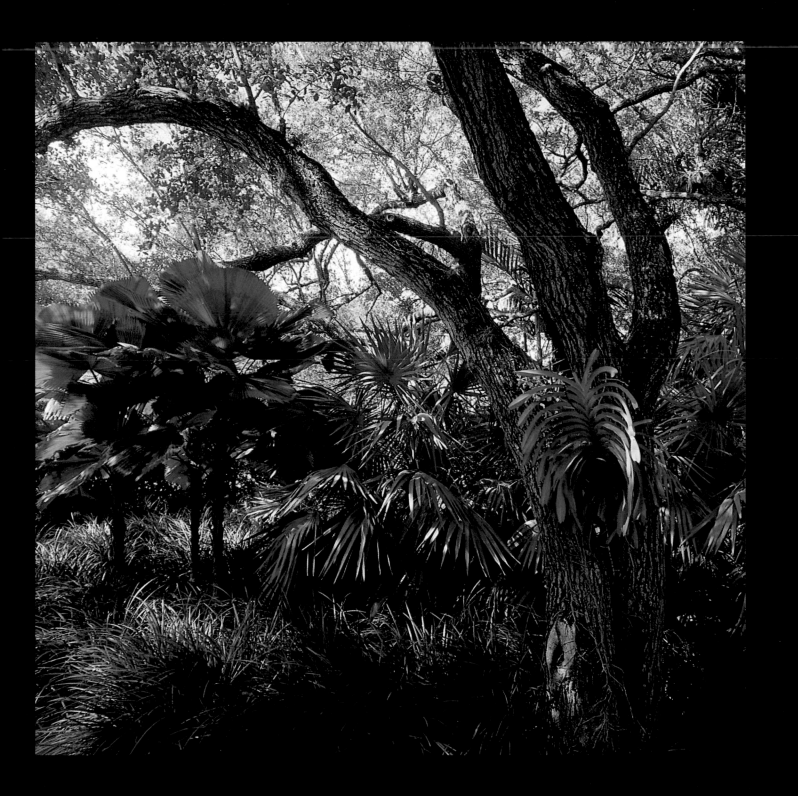

Raymond Jungles was destined to find a calling which would enable him to spend a great deal of time with nature. He was exposed to the grandeur of Yosemite, Sequoia, Baja, the Pacific Beaches, and the desert while living in Southern California as a child. Hiking and camping were passions he pursued during later years growing up in the midwestern states of Nebraska, Illinois, and Ohio.

A spring break visit to Florida enticed Jungles to return after graduation from high school. Ultimately this led to graduation with honors from the University of Florida, in 1981, with a Bachelors of Landscape Architecture degree. While at the University, he met his mentor Roberto Burle Marx who was a visiting lecturer in 1979.

Jungles worked his way through college as a landscape laborer and designer doing small residential gardens. For his senior thesis project, Jungles undertook the re-design the entire Miami Bayfront Park System. During this process he had access to the conceptual sketches of Noguchi, whose design was implemented on the southern portion of the Bayfront. Noguchi's graphic representation of soft colored pencil sketches, and his intuitive, seemingly unstructured design approach, had a lasting impact on Jungles.

His only experience in a professional landscape architectural office was obtained as an intern in the Miami office of O'Leary-Shafer-Cosio between his sophomore and junior years at the University of Florida.

While running his own design-build company in 1981, Jungles again had the opportunity to meet Burle Marx

on one of his frequent visits to Miami. That same year, Jungles traveled to Brazil. A close friendship developed. Jungles made annual visits to Burle Marx in Brazil and he began staying with Jungles and his family while visiting Miami. Priceless insight and experience was gained during the time spent with the generous, brilliant master. "Burle Marx is immortal. He still influences me daily. Things he said, his humor, his way of being. I was extremely fortunate to have known this great genius and warm soul," says Jungles.

In 1983, Jungles married Debra Yates, an abstract artist. Debra also credits Burle Marx with influencing her bold, colorful, ceramic murals which adorn walls and fountains designed by Jungles.

After several years of design-build, Jungles formed Raymond Jungles, Inc., preferring to concentrate on design related services. Jungles' practice expanded rapidly and at one point in 1990 his studio of six was juggling a hotel on Miami Beach, a large clubhouse and country club, three communities, and several large estates. Jungles decided that the administration of so much work was impacting his freedom to design. He began concentrating primarily on residential and estate gardens, paring his studio down to its present staff of himself, his assistant Craig Reynolds, and draftsman David Odishoo.

Jungles' assistant, Craig Reynolds, holds a bachelors degree in fine arts from Ohio State University and a Masters of Landscape Architecture from the University of Florida. Craig interned with Jungles during his graduate studies and began working with him full time in the summer of 1996. "Working with Raymond is akin to the relationship between artist and apprentice, much like Jungles learning under the tutelage of his mentor Burle Marx," says Craig.

Jungles' draftsman, David Odishoo, has worked with Jungles since 1989. David balances his career as a musician and draftsman while running Jungles small Miami office.

In 1997 Jungles relocated his design studio to Key West, Florida. Jungles spends as little time in the studio as possible during the day, preferring to design in the early mornings, evenings or on weekends. He spends most of the daylight hours on-site, designing, laying out, or observing the implementation of his gardens. Most of his projects are in south Florida, from Palm Beach south to Key West.

Jungles' work has been published in over twenty-five local, national, and international publications. Projects have also been featured in five books, including *The New American Garden*, by James Grayson Trulove.

The Florida Chapter of the American Society of Landscape Architects has given twelve design awards to his projects, seven of them Awards of Excellence. Numerous other awards have been given to his projects by other organizations.

Jungles is known for his knowledge of plant material and is often a guest lecturer at garden organizations and universities.